WITHDRAWN

P9-EDI-245

THE SECRETS OF
LEGO® HOUSE

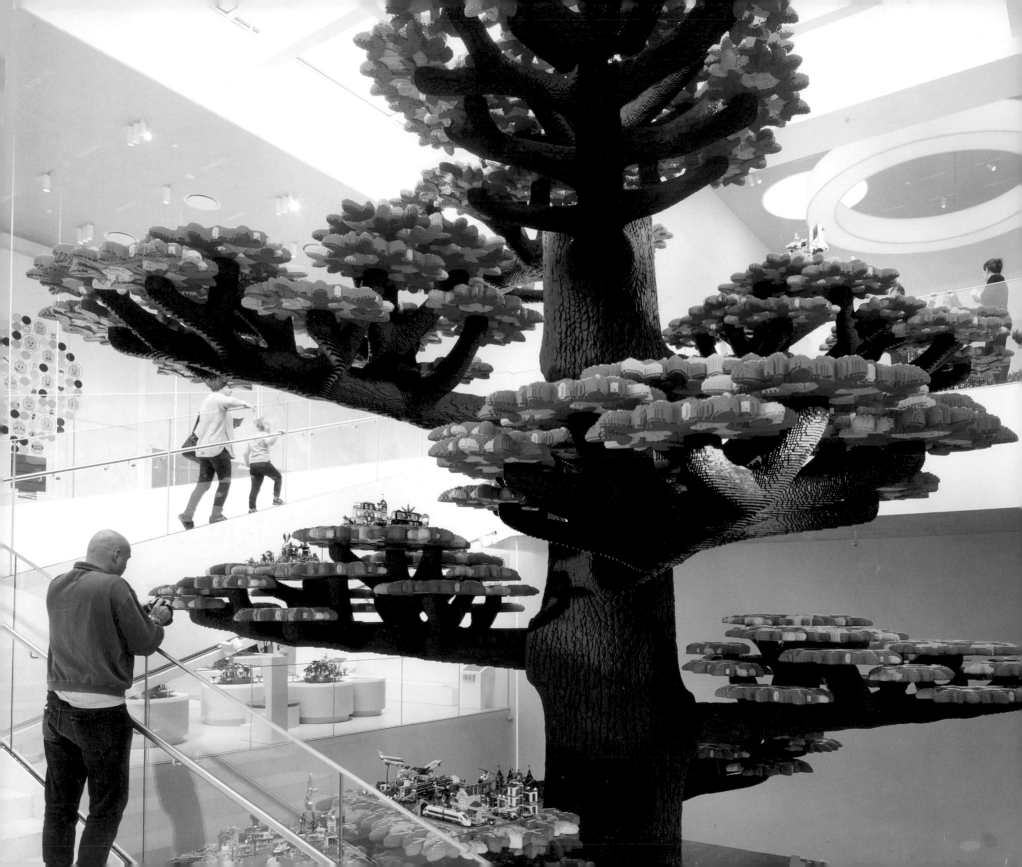

THE SECRETS OF
LEGO® HOUSE

Design, Play, and Wonder in the Home of the Brick

by Jesús Díaz
Foreword by Jesper Vilstrup, Managing Director, LEGO House

CHRONICLE BOOKS
SAN FRANCISCO

LEGO, the LEGO logo, the Minifigure, the Brick and Knob configurations, the DUPLO and the DUPLO logo, FRIENDS and the FRIENDS logo, NINJAGO and the NINJAGO logo, BIONOCLE, MINDSTORMS and LEGOLAND are trademarks and/or copyrights of the LEGO Group.
©2021 The LEGO Group. All rights reserved.
Manufactured by Chronicle Books, 680 Second Street, San Francisco, CA 94107 under license from the LEGO Group. Made in China by C&C Joint Printing Co., Shanghai, China, May 2021.

© & ™ 2021 Lucasfilm Ltd.

© Disney

WIZARDING WORLD characters, names and related indicia are © & ™ Warner Bros. Entertainment Inc. WB SHIELD: © & ™ WBEI. Publishing Rights © JKR. (s21)

© 2021 Mojang Synergies AB. All Rights Reserved. Minecraft, the Minecraft logo and the Mojang logo are trademarks of the Microsoft group of companies.

© 2021 MARVEL

Photographs copyright © LEGO® House

Photographs on pages 58, 76 (far left), 78-79, 83, 94, 95 (left top and bottom), 98, 100, 101 (bottom left and right), 103, 126, 127 (top), 135 (bottom), and 143 (left top and bottom) by Jesús Díaz.

All rights reserved. No part of this book may be reproduced in any form without written permission from the publisher.

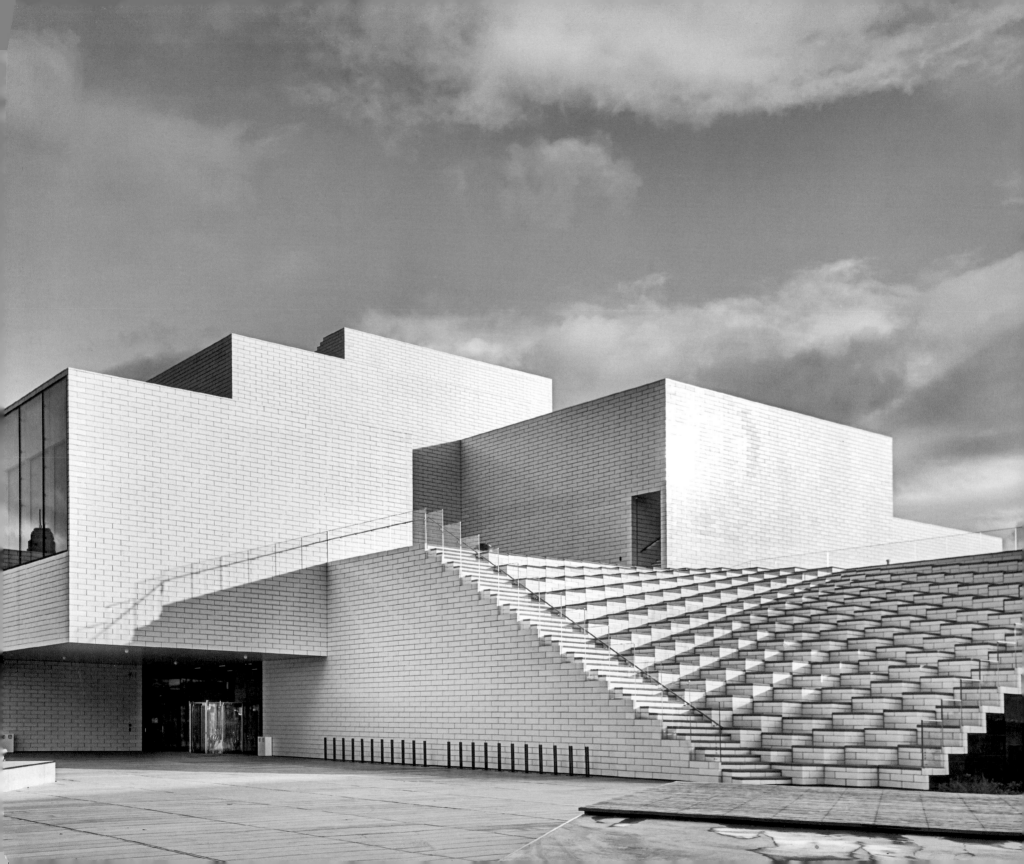

CONTENTS

FOREWORD
By Jesper Vilstrup, Managing Director, LEGO® House

When I first joined the LEGO® House project years ago, one of the many conversations we had as a team was, how do we make it all come to life? Was it going to be a museum or a place to have fun with bricks? Or both? After some consideration, it was clear that it had to be something very different. Kjeld Kirk Kristiansen, third-generation owner of the LEGO Group, was the driving force behind the project. His vision was to make this place the "Home of the Brick." And that meant that it had to become the physical manifestation of the LEGO brand at its very core: the Learning Through Play philosophy.

We decided to use the Learning Through Play approach to design everything in the LEGO House. In fact, the LEGO House had to be the ultimate expression of the Learning Through Play experience. Every aspect of the building and the experiences, including all 25 million bricks that live within the walls, had to serve that function. And ultimately, it also had to be a fun place where people come to enjoy themselves with family, friends, or colleagues.

Our ambition is that the children and adults who experience the LEGO House will learn something while having fun, but without necessarily knowing they are learning. And our hope is that some visitors will be transformed by the journey in an even deeper way. Perhaps, one day, some of our guests will look back and remember the LEGO House experience that made them want to become an architect, an engineer, or an artist—that tiny moment where everything clicked in their lives.

For us, applying the Learning Through Play philosophy throughout the LEGO House was also a *click moment*. It was crucial to articulate Kjeld Kirk Kristiansen's vision and it became the compass for everything in the building, from the experiences to the way people move from zone to zone. It gave all of our work and planning a definitive, but invisible, purpose. And by doing so, it became the secret of the LEGO House.

This book documents that secret. You can think about this volume as the building instructions to the LEGO House. If you have already been here, perhaps reading about this powerful learning and creativity philosophy will spark your curiosity to dive deeper into it—maybe even use its powers in your own life. And if you haven't visited the LEGO House yet, maybe it will move you to come to Billund and take the journey yourself.

PART I:
CONNECT

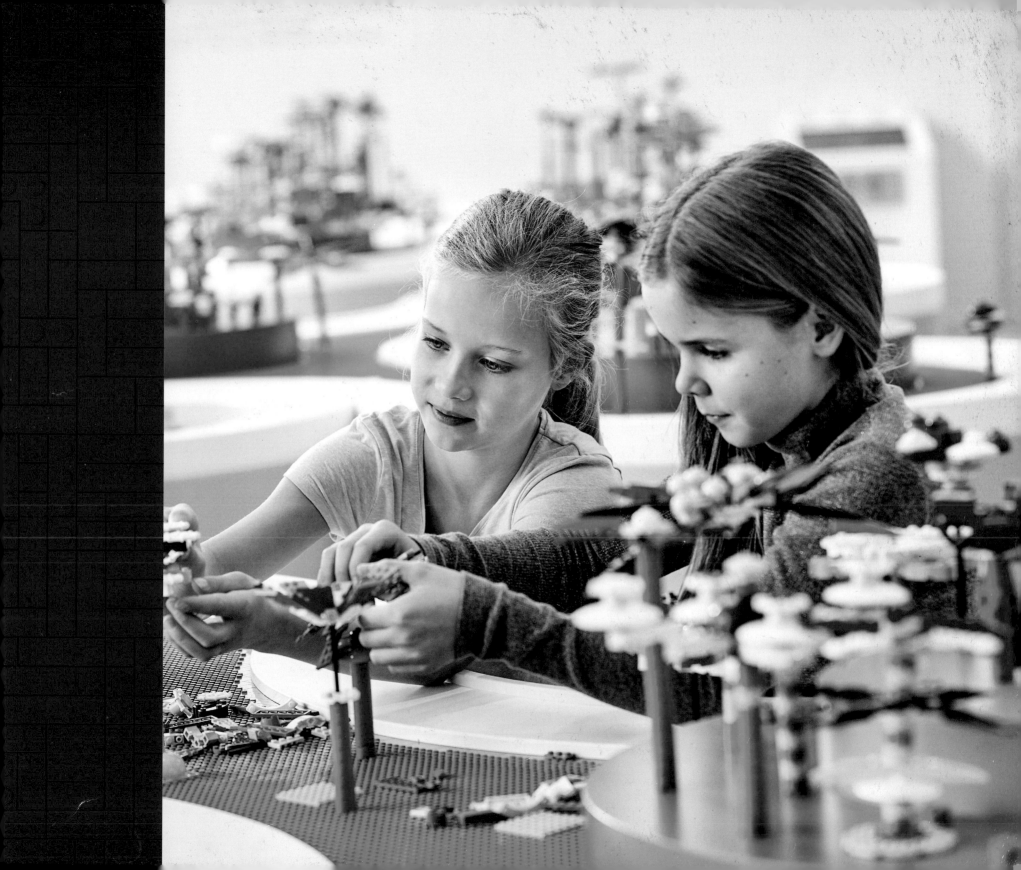

LEGO® DUPLO® Brick Builder

We are all born with a creative urge. Young unspoiled minds simply are creative, and a child will by nature approach the world in a playful manner. But creativity is a fragile thing, and it is an important and delicate task to nurture this amazing human ability.

Take every opportunity to encourage your child's creativity. When they struggle, help them get over the hurdle. When they talk about their creations, listen carefully and ask curious questions. When they fail, encourage them to try again. By working together with your child, you can nurture the creativity within and pave the road for a creative future.

WOW.
The true power of the brick.

Top: Freshly minted minifigure heads tumble down the line at a LEGO factory.

Bottom: The LEGO Duck, shown here on display at the LEGO Idea House, was released in 1936 and is iconic of the early wooden toys that the company produced.

The first time I visited Billund in 2008, I was going through a rough patch in my personal life. I had left sunny Madrid with my then wife to live in ominous London. It wasn't a good fit, and the iron sky permanently hanging two feet above my head didn't help things. Still, I remember that the day I arrived in that tiny town in Denmark, I was happy. After spending my younger years playing with LEGO® bricks in the company of my three siblings and my dad, I was in Billund on assignment. My editor at Gizmodo.com had sent me to write a series of articles on "anything cool you can find there." And oh boy, did I hit the jackpot of all things cool. I was a pilgrim about to enter the Mecca of my childhood dreams.

The LEGO factory left me, a total nerd, speechless. I saw giant molding machines churning out 2.16 million bricks per minute from an endless flow of ABS plastic heated to 450 degrees Fahrenheit (235 degrees Celsuis). Hundreds of robots took those pieces and put them in 68-foot-tall (20.7-meter-tall)

cathedrals, vertigo-inducing storage rooms that hold 19 billion LEGO elements per year waiting to be packaged into sets and sent all over the world. With my head spinning, I thought this was going to be the best moment of the trip. But that actually came later in the day, when the company's chaperone took me to a place called the LEGO® Idea House.

The LEGO Idea House consists of three important buildings: Ole Kirk Kristiansen's family home and office, the wooden toy factory, and the Systemhouse, which served as the LEGO Group's first administration building and headquarters. The Idea House is home to a museum, a private space in which only employees and special visitors are allowed. In this place you are treated to a tour of the company's history, packed with original artifacts to help you understand the story behind the LEGO Group.

The head of the Idea House, Jette Orduna, guided me through the company's time line. It was all interesting, and

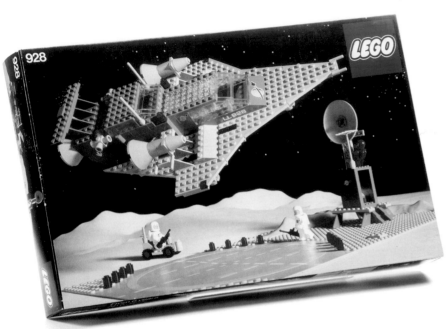

Above: LEGO Space Cruiser and Moonbase, set #928. Also known as Galaxy Explorer, this set was given the number 497 in the United States for a special reason. If you multiply the four digits of the year of the Apollo 11 moon landing, 1969, you get 486. Then add 11, representing Apollo 11, and you have set #497.

Right: US patent #3,005,282 for a "toy building system" by Godtfred Kirk Christiansen. The original Danish patent is dated January 28, 1958.

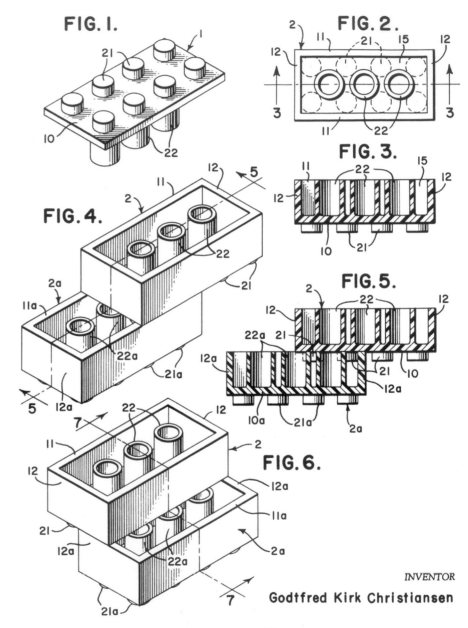

FIG. 1.
FIG. 2.
FIG. 3.
FIG. 4.
FIG. 5.
FIG. 6.

INVENTOR
Godtfred Kirk Christiansen

BY
Stevens, Davis, Miller & Mosher
ATTORNEYS

then she took a shortcut out of the public area. Then things got *really* interesting. On this hidden path I noticed some stairs going down *somewhere*. I peeked and saw a nondescript door with a digital code lock and the words "Memory Lane" set in LEGO bricks. "What's in there?" I asked her. "That's where your childhood dreams sleep," she answered. "Want to see it?" Well, *duh*—of course I wanted to see it.

She went ahead and opened the door. Inside we found a beige room with a line of fireproof museum-grade storage cabinets to the right. Some of them were open, and I saw the boxes. Here was the most amazing treasure trove I could have ever imagined—almost every single LEGO set ever made was there, Orduna told me. I couldn't believe it. I grew up playing with some of these very same sets. My brain is etched with perfect memories of my father, brothers, and sister playing with those bricks on a rug in the living rooms. Just as Orduna had described, my childhood dreams were sleeping in this basement.

She showed me the first plastic brick toys, still imperfect in their design. Then I saw a train that could be activated with a whistle, which I vaguely remembered. My father had probably brought it to us from one of his trips to Sweden, but I was too young, so I only had flashes of it in my brain. I was enjoying it all like an archeologist exploring the physical origins of an ancient myth.

Then we got to the 1970s shelves and started to dig around. Without telling me, she started looking for something I had mentioned earlier in my visit. Then I heard her say, "Aha! Here it is!" as I saw her taking out a set from a line of boxes with yellow rims.

It was the LEGO® Galaxy Explorer from 1979—the very first set I clearly remember my father giving to my brothers and me. Old images fired in my cortex. A tsunami of emotions drowned me. And then the tears came.

"You know that it happened hundreds of times after it happened to you?" Orduna told me more than a decade after that moment, this time over hot coffee and Danishes while the new LEGO House protected us from the typical cold drizzle of early spring. From old LEGO fans to completely random visitors, almost everyone who visits the Memory Lane room experiences the unexpected flashback to a moment in their childhood, so vivid and powerful that it makes them emotional. "It's very powerful stuff," she said. Thinking back to my first trip to the secret vault, "very powerful stuff" was an understatement. Nothing could have prepared me for the overwhelmingly evocative power of a simple box full of gray, blue, and yellow LEGO bricks.

OH, I GET IT.
This is what the LEGO® System really means.

After my first visit to Billund in 2008, that Gizmodo article about how old LEGO® sets were not just bricks in a box but a time portal to days long forgotten went viral online. In it, I called the basement archive "the secret vault." According to LEGO Idea House head Jette Orduna, that article brought TV channels and newspapers from all over the world to the Idea House—all to see the "vault." And like any other visitor, the most serious journalists in the world had the same reaction. "It doesn't matter who they are, they come, and at the end, they all get emotional," she said.

This unprecedented demand to visit Memory Lane was one of the things that made Kjeld Kirk Kristiansen decide that the company needed a place for everyone to come and feel the power of the LEGO experience firsthand. However, the third-generation company owner—grandson of Ole Kirk, son of Godtfred Kirk—wanted to create more than a nostalgic museum or a fun house full of LEGO models. He wanted this place to be "the Home of the Brick," to physically represent everything the company believes in. Kristiansen thinks that the colorful bricks transcend their simple nature as toys. And so the LEGO House became his mission. He got involved in every aspect of bringing it to life because he believes it is his legacy and a testimony to how these bricks are a lot more than just pieces of plastic. For him, it all has a higher purpose, and the Home of the Brick needed to show it.

For Kjeld Kirk Kristiansen, the LEGO brick is intimately tied to some of the dearest memories of hundreds of millions of people throughout the world for a reason—one that's even larger than the joy of playing with a building toy. This higher purpose helps us *become* adults by transforming us—our minds and spirits, and our view of the world as we play. It's a secret hiding in plain sight for everyone who has ever clicked LEGO bricks together.

That secret is Learning Through Play.

The LEGO Foundation was established in 1986. It aims to build a future where learning-through-play empowers all children to become creative, engaged, life-long learners. Through 25% ownership of the LEGO Group, the LEGO Foundation has helped fund programs that ensure children across the world learn and develop holistic skills through play. The organization was born of the theory and practice of learning-through-play, a scientifically researched method that says that human beings learn most effectively not by memorizing, listening, or seeing others doing things, but by *playing*. According to Tina Holm, research manager at the LEGO Foundation, the philanthropic organization has worked for more than five years with academic researchers around the world—such as the MIT Media Lab in Cambridge, Massachusetts—to codify this theory, an ongoing work that hasn't been completed yet. This creative learning model, which they refer to as the "Journey," goes through three distinct phases: a connection phase that makes people of all ages curious and motivates them, an exploration phase in which people test and try things, and a transformation phase in which people reflect and communicate.

Kristiansen, convinced that Learning Through Play is the very core of the LEGO experience, wanted this methodology to be central to the Home of the Brick itself and its guiding ethos. In fact, the LEGO Foundation joined the project to help the LEGO House design team integrate Learning Through Play in everything. And thanks to this focus, everything clicked perfectly, materializing Kristiansen's vision for the Home of the Brick.

The Learning Through Play model is based in five development competencies —social, creative, cognitive, emotional, and physical—and the three-phase learning process of connection, exploration, and transformation. The five development competencies actually served to organize the architectural space—as we will see in part II of this book—while the learning process guided the design of every single experience inside the LEGO House and, more importantly, the rules that governed its design team's creative work.

To better explain how the three phases—connect, explore, and transform— work, I want to go back to Christmas morning, 1979, when my siblings and I got the Galaxy Explorer and other smaller LEGOLAND® Space sets.

In the connect phase I became instantly enthralled by the model pictured on the box. It's what the LEGO Group calls the *"wow" moment*. My mind marveled at the amazing spaceship, the lunar station, the little astronauts with their smiling faces. Then I opened the box and saw the transparent round boxes with all those blue, gray, and yellow bricks, plus a large instructions booklet. As a child, this was when I understood that the objective of this set was to build that

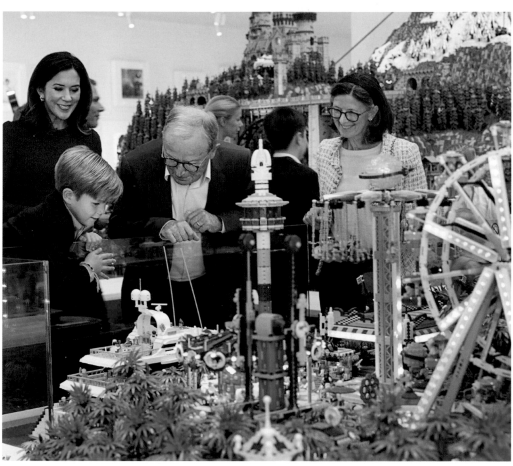

Left: Three generations of the Kirk Kristiansen family helped lay the foundation stones of LEGO House.

Above: HRH Crown Princess Mary, HRH Prince Vincent, Kjeld Kirk Kristiansen, and Camilla Kirk Kristiansen take in the wonders of World Explorer in the Green Zone at the Grand Opening.

scene—the *"Oh, I get it" moment*—and what *I* was supposed to do with it: what the LEGO House team refers to as the *understanding my role moment*.

The explore phase starts with something called *first fun*. This happened when I opened the first page of the instructions booklet and started selecting and sorting the pieces I needed to put together the ship's cockpit, imagining how each brick would contribute to the finished set. After that, the *immersion* stage took over. I became so engrossed with what I was doing that everything disappeared around me. My brain was working at full speed, interpreting the building instructions while using my eyes and hands to find specific pieces, clicking them together in the right way. As I completed segments of the spaceship, I had what the LEGO House team categorizes as *"aha!"* moments, where I stopped to recognize the progress I was making and take in how every-thing was coming together.

The transform phase is what makes you grow as a human being, the part where everything gets organized in your mind as knowledge and skills. In this example, it begins with the *end point moment*, when I finished the model. My brain, after all those inputs and outputs, was satisfied. As I held the Galaxy Explorer in my hands, opening and closing its cockpit or docking bay, making a littler rover go inside that bay, or placing a spaceman in the little lunar outpost, my mind was processing and reflecting on everything I had done. Inevitably, the mental and manual chal-lenges of the building experience trans-lated into a feeling of pure joy, which served to integrate the acquired knowl-edge into my core self. This is what the method calls the *lasting impression*. Finally there is *sharing*: the mere fact of articulating learned knowledge helps you further clarify it for yourself. According to Holm, research shows that sharing with others helps "fix" knowledge in our brains. My brothers and I showed off our accomplishments—a finished Galaxy Explorer—to each other and to my dad, because that's what humans do.

Of course, I had no idea what was happening in my young brain until I came to the LEGO House. Now, looking back at that and many other episodes, I can see how the logic of the Learning Through Play model has ruled every aspect of my creative journey through my young and adult life. If you analyze your own experiences playing with LEGO bricks or anything else, you may see how this model applies to your life too. And perhaps this book will empower you to take advantage of this model in your daily life—to learn, create, or teach others about your own experiences and journey.

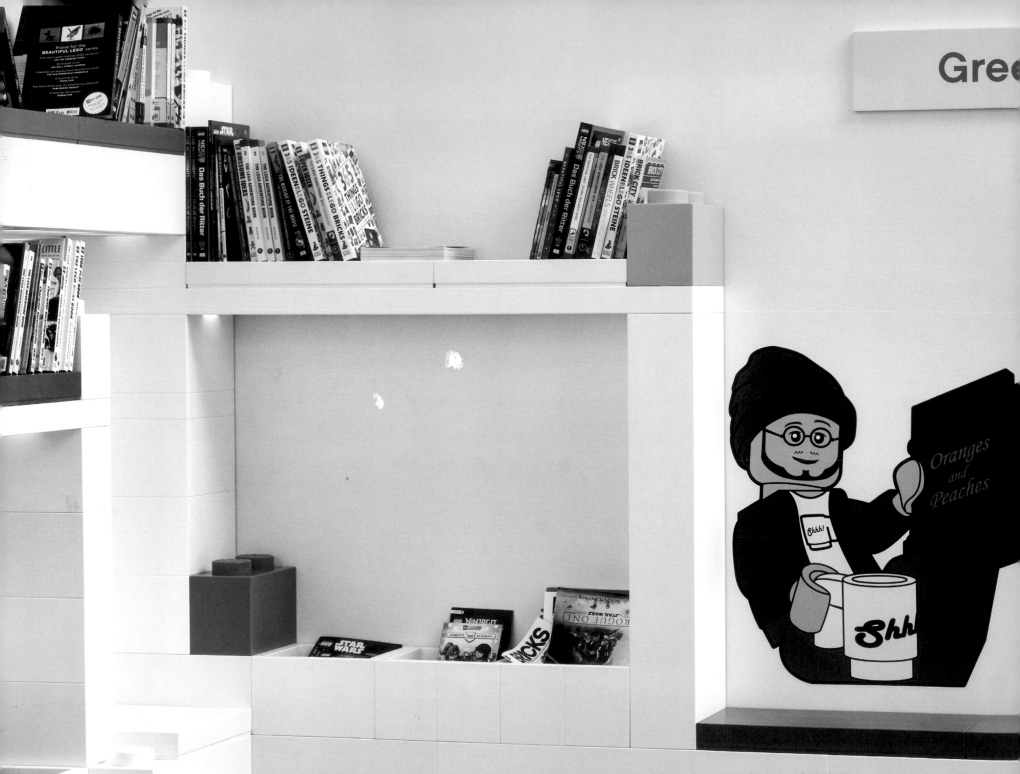

YOUR ROLE.
A philosophy for life.

Opposite: The Library, located in the Red Zone, is home to a large collection of LEGO books—the perfect spot to recharge and seek out inspiration. Maybe one day someone will read these words from this very spot!

The three phases at the heart of the Leaning Through Play philosophy are actually intrinsic to our growth as humans. Like other mammals,[1] we learn skills and gain knowledge through play on a regular basis. We do it more as kids, of course, as we have more things to learn at that point, to guarantee our survival and to thrive as a species. Through our early years, we play with other people and objects, often building complex things out of simpler elements, such as putting together a car with an old box and some pieces of wood. That is exactly the process that LEGO® bricks fulfill, providing basic pieces to build increasingly complex objects. As adults, the play is still there sometimes—especially in hobbies we enjoy—but not as much in other aspects of our day-to-day lives. As I learned at the LEGO House, these competencies are as important to our development as subjects we learn in school, college, or our professional lives. They are the fundamental blocks that enable us to survive and progress in a meaningful way, even while the process may be misunderstood or dismissed by most.

As you explore this book, no matter whether you have been to the LEGO House or not, remember the "secret" built into everything and at the core of the LEGO experience: The Learning Through Play philosophy is the purpose of the House, the method that guided its creation, and the model that rules every aspect of its structure and experiential installations. Even this book is organized by the stages of the learning process.

And while the secret may be invisible, you will discover that it lingers in every corner of the Home of the Brick. People don't get it at the conscious level, but they *get* it. It's just like me putting together the Galaxy Explorer: Your brain is activated, your excitement builds, your patience and problem-solving skills are tested, but you don't think, "Hey, I'm learning something." You just do. The LEGO House has that same effect. As

[1] Marek Spinka, Ruth C. Newberry, and Marc Bekoff. "Mammalian Play: Training for the Unexpected." *The Quarterly Review of Biology*. Vol. 76, No. 2 (June 2001), pp. 141–168. https://www.jstor.org/stable/2664002

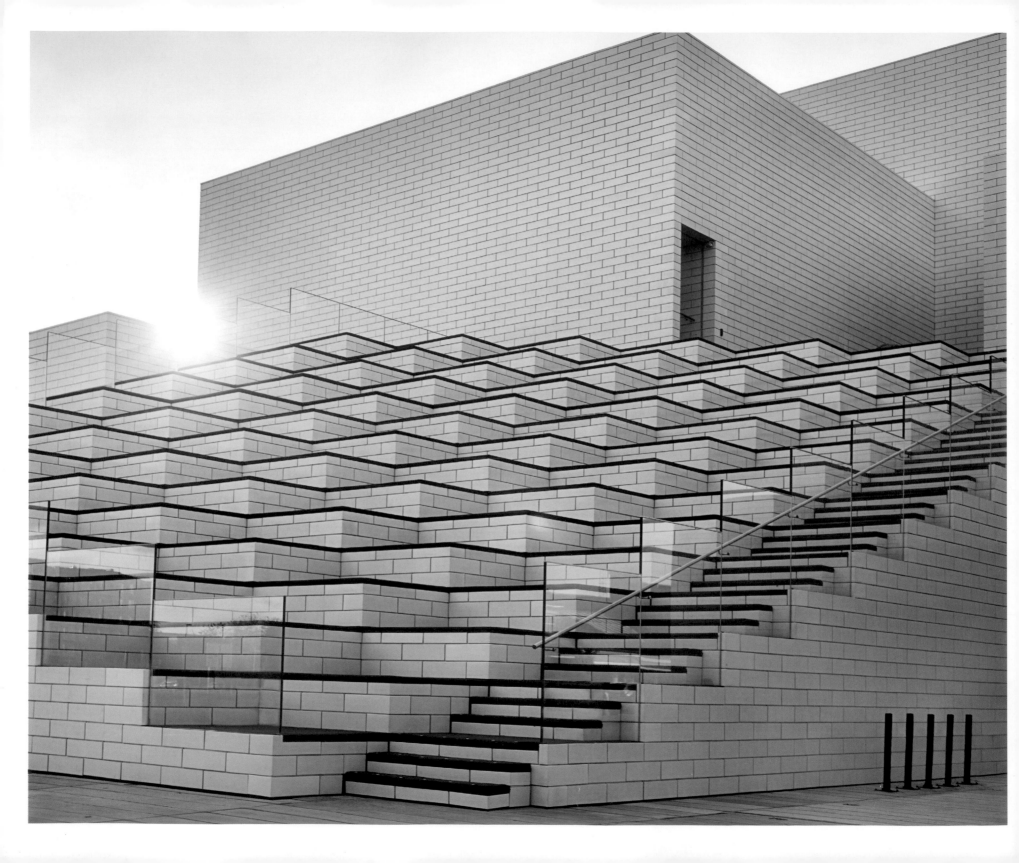

head of Idea House Jette Orduna put it, "It resonates. And that's why you go, 'Oh wow, this is something special.' The [LEGO House] becomes a definition of the brand itself and all that the product stands for."

And thus, arriving at the building becomes the connect phase of the LEGO House, an architectural structure that *wowed* me from the moment I set eyes on it, and again as I entered and found the giant steel staircase suspended by four steel beams in the middle of the building's hall. Wrapped around the breathtaking Tree of Creativity—a 52-foot-high (16-meter-high) LEGO model that narrates the entire history of the company—the staircase is an irresistible invitation to explore the LEGO House. I automatically *got its purpose* and understood that *my role* was to discover the treasures inside.

Then, the experiences inside each zone become steps in an exploration journey through the LEGO House. As you will see later in these pages, each of these are organized by the three phases of the Learning Through Play method—like galaxies within a universe. From the moment you reach your first experience and have your *first fun* to the *"aha!"* *moment* at the end of your journey, you get fully *immersed* and the world disappears as you focus, spending much more time that you could have ever imagined building things and finding solutions to dozens of problems.

And finally, in the basement, there is time for transformation. In the History Collection—the LEGO House version of the Memory Lane "secret vault" I discovered back in 2008—the lights dim, the walls darken, and even little kids go quiet. It's a place that invites you to reflect. This is where our journey *ends*. Where guests can process a *lasting impression* and *share* memories just made or long lost in time.

If the LEGO House is the Home of the Brick, the History Collection is where the brick sleeps and dreams the memories of the millions of people who once played with the sets stored there—the central core of the LEGO universe. And if the bricks contained in its concrete walls are the elemental particles of this universe, then Learning Through Play is its theory of relativity, the set of rules that govern it all.

That's the real secret of the LEGO House, one that, as Kristiansen believes, transcends the physical nature of colorful plastic bricks. As this book guides you to explore how Learning Through Play shaped LEGO House, perhaps this philosophy can help you transform the way you build your life too, hopefully improving your learning and creative powers in the same way it helped LEGO House creators and designers refine their own skills and apply the creative process.

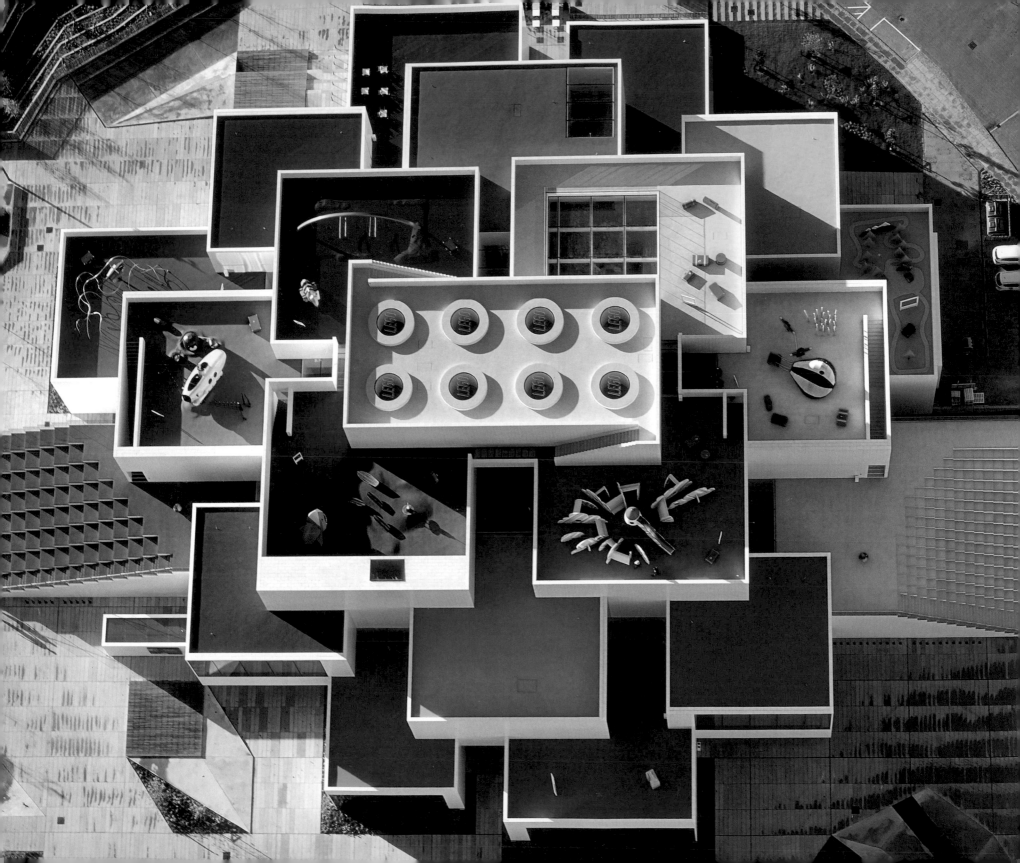

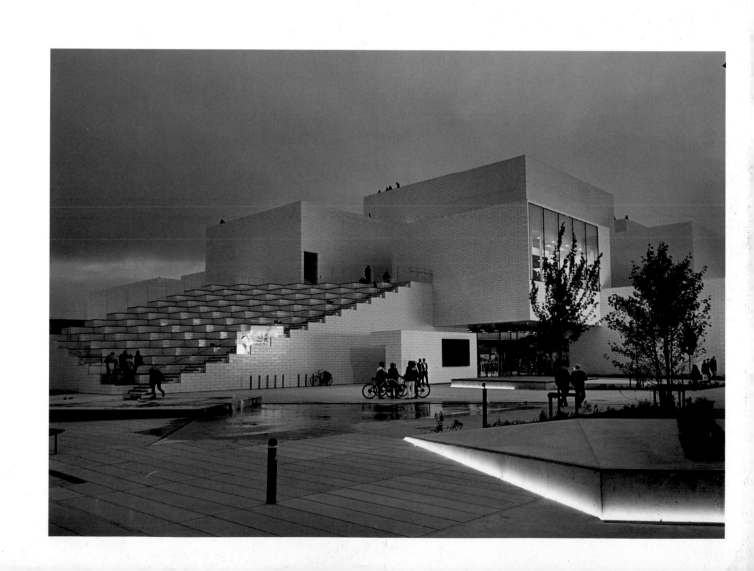

The Creative Lab in the Red Zone is a permanent workshop for builders of all ages. It challenges guests to build a specific thing, with no rules except that they must work from a limited set of brick types specifically selected by the experience designers.

Opposite: Character Creator in the Green Zone offers the opposite experience. Guests are encouraged to build their own minifigure from an endless supply of options. Pools filled with tens of thousands of legs, torsos, hands, heads, hairpieces, hats, helmets, and shields offer any combination a guest can dream up.

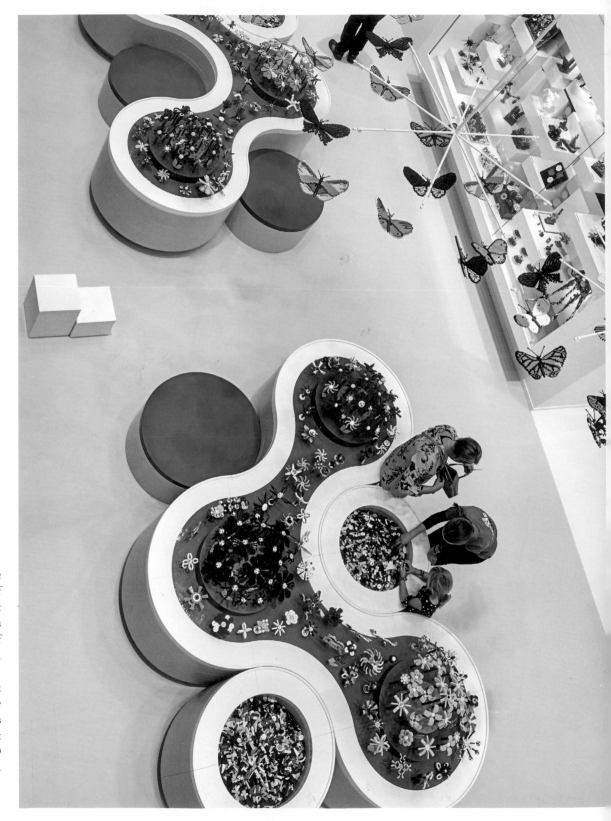

The Flower Artist experience in the Yellow Zone introduces a moment of respite in the activity of the LEGO House. Placed under a flock of giant butterflies made of LEGO bricks, it invites guests to build flowers against a grand view of the Tree of Creativity. It's a place of meditation and calm.

Opposite: In the Farewell Zone guests collect six red 2x4 LEGO bricks and a card showing their very own, one-of-a-kind, six-brick combination. This unique memento of LEGO House reminds guest of their own personal connection to the LEGO System in Play.

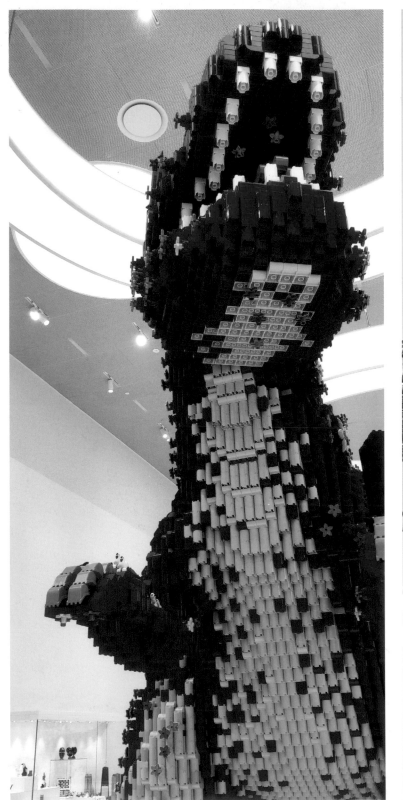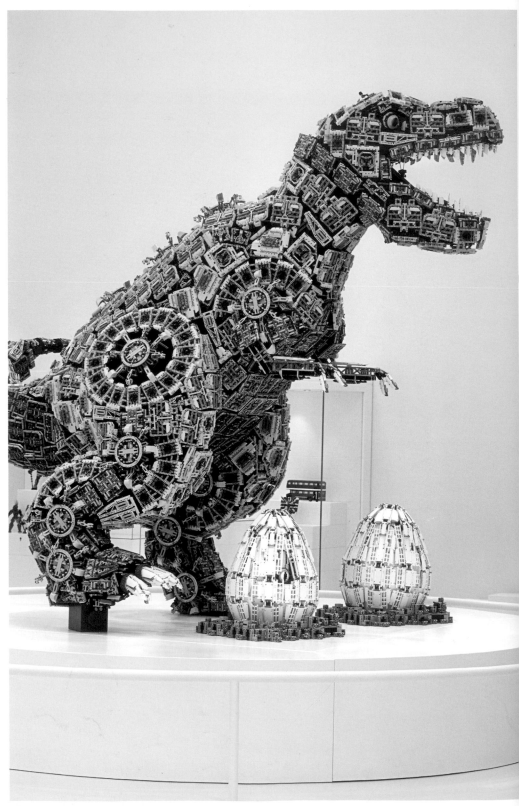

The majority of walls and ceilings in LEGO House are pure white, with only a few exceptions. The colored tiles in the main staircase are reminiscent of an original façade design, where one of the twenty one outer blocks was to be multicolored. This idea was later scrapped in favor of the all-white façade seen today.

Opposite: The Masterpiece Gallery at the very top of LEGO House is built around three roaring dinosaurs, created from LEGO® DUPLO®, LEGO® System, and LEGO® TECHNIC elements. The Duplosaur, left, was a challenging model because of the limited range of LEGO DUPLO pieces. LEGO model teams reached some very creative solutions, like using excavators to create the dino's claws.

The Technicosaur, right, was the most challenging of the three dinosaurs. During its creation, adult fans of LEGO found a clever new way to work: rather than using individual elements to build the entire thing, they created smaller assemblies that could be repeated many times over and put together to form surfaces on the dino's body.

PART II:
EXPLORE

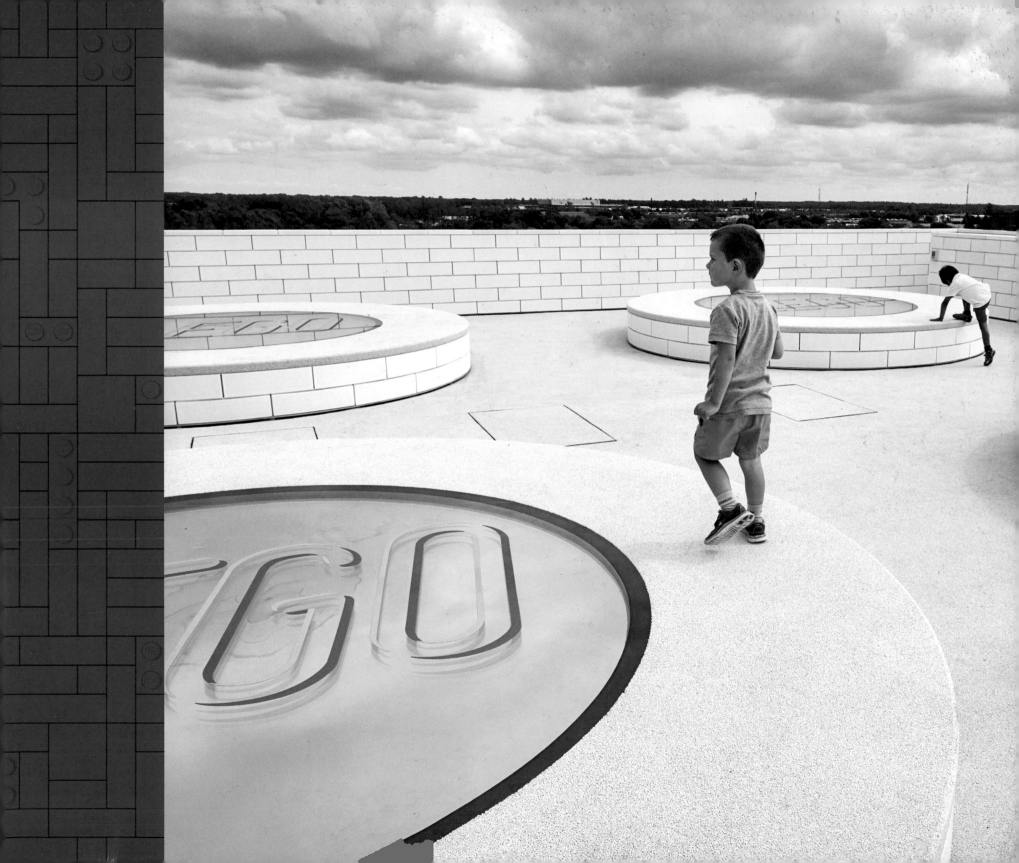

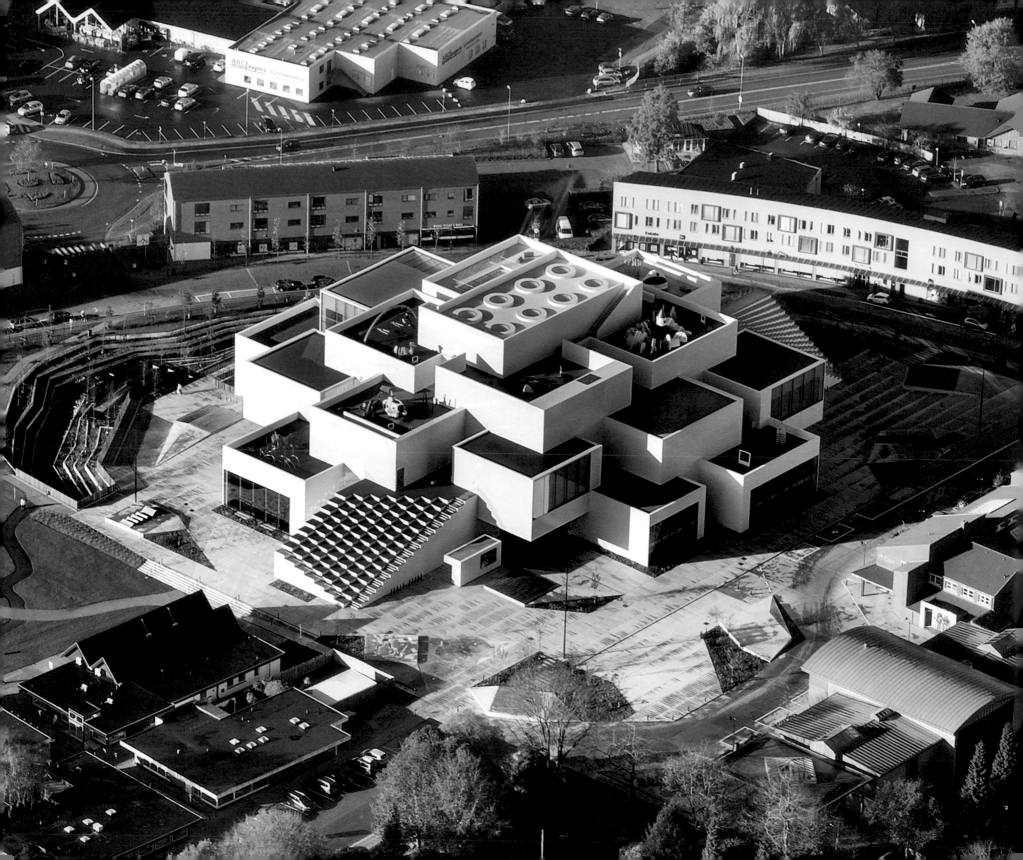

FIRST FUN.
Designing the Home of the Brick.

A working model of LEGO House helped designers keep everything in perspective.

Following spread: Bjarke Ingels, founding partner and creative director of the architectural firm BIG.

If you were in the International Space Station orbiting over Denmark right now, you would be able to look down with some powerful binoculars and see a big colorful boxy building about 165 miles (250 kilometers) west of Copenhagen—a building seemingly made of giant LEGO® pieces.

After the initial surprise, you would be able to count *twenty-one* giant red, green, yellow, and blue blocks, with one titanic white 2x4 brick right at the top of it. At that *"wow"* moment, you would probably leave your binoculars floating in the ISS observation module, grab a laptop, and fire up Google. Within seconds, you would discover you were looking at the center of the known brick universe: the LEGO House, located in the humble Danish town of Billund.

A LEGO House has to be made of bricks, *of course*. How else could you design a building that embodies not only the brand, its history, and its ethos, but also, more importantly, the dreams of

the millions of people who share an emotional connection to the most popular toy in the world? It couldn't be any other way.

That was exactly what Bjarke Ingels thought, when the LEGO Group announced its competition to design the LEGO House. The award-winning Danish architect and founder of design firm BIG is a lifelong fan of the toy. Ingels grew up building sets during the late 1970s, the golden era when the company—then led by Kirk Kjeld Kristiansen—took over the world with its first official play themes after years of selling basic colorful sets: LEGOLAND® Space, LEGOLAND Town, and LEGOLAND Castle. Ingels's first LEGO set was in fact the 1978 Yellow Castle, which perhaps was the Learning Through Play experience that sent him into his journey to become an architect.

Ingels knew that he had to win this project no matter what. "If BIG had been founded with the purpose of building just one building, this was going to be the

building," he said when the LEGO House opened in 2017.[1] His first sketches focused on twenty-one interlocking galleries that would encapsulate a central town hall–like space. This design would endure throughout the entire process.

Ingels's personal fandom is so strong that he actually built a model of the LEGO House in the style of a LEGO Architecture set and brought it to the pitch at the company's headquarters in Billund. The model immediately won the heart of Kjeld Kirk Kristiansen. For Ingels, the building had to be so true to the nature of the familiar brick that he vowed to design everything so it could be built at any scale using LEGO bricks. And thus, everything in this structure had to respect the proportions of the 2x4 brick, which is the core building block of the LEGO System. In fact, Ingels believes that the 2x4 brick holds the secret golden ratio of architecture itself.

Obviously, the fact that Ingels was such a big fan of the product was important for Kristiansen. If the LEGO House had to embody the spirit of the LEGO brand and be the Home of the Brick, everyone involved in the conceptualization, its experiences, and the models featured inside must have an emotional connection that went beyond the logical understanding of its brand and its ethos. The LEGO House had to be built by people who love LEGO bricks for people who love LEGO bricks.

One example: Remember that gigantic white brick atop the LEGO House? It was partially a fan idea. "We talked with fans all through the process of planning the House," Stuart Harris, senior experience designer of LEGO House, told me. While BIG designed a topmost brick as an architectural keystone, turning it into a 2x4 brick complete with windows was a fan suggestion. If an alien came from space . . . that's how they would know this is a LEGO House," Stuart explained. For that alien—just like for you in your imaginary ISS journey and for every visitor to the LEGO House—the building itself would be a *"wow"* moment.

A LEGO House made out of LEGO bricks may seem obvious now, but it wasn't a decade ago, when the idea for the LEGO House started to brew in Kristiansen's mind. "We had a long journey," Jette Orduna, head of the Idea House, told me. "Originally, Kjeld and I had a discussion in 2005 about making access to the LEGO Idea House open to the public or if we should keep it to LEGO employees only." Eventually, they discarded the notoin because it was too complicated—the Idea House wasn't big enough to contain everything they needed.

It wasn't in the right place either. The LEGO House had to be located right in the very center of Billund. Arrangements were made to buy the plot where the city's town hall had previously stood, a central location that had recently been put up for sale. That space made

[1] LEGO House official video. LEGO Group. August 16, 2017. https://youtu.be/obctNB3_f_M

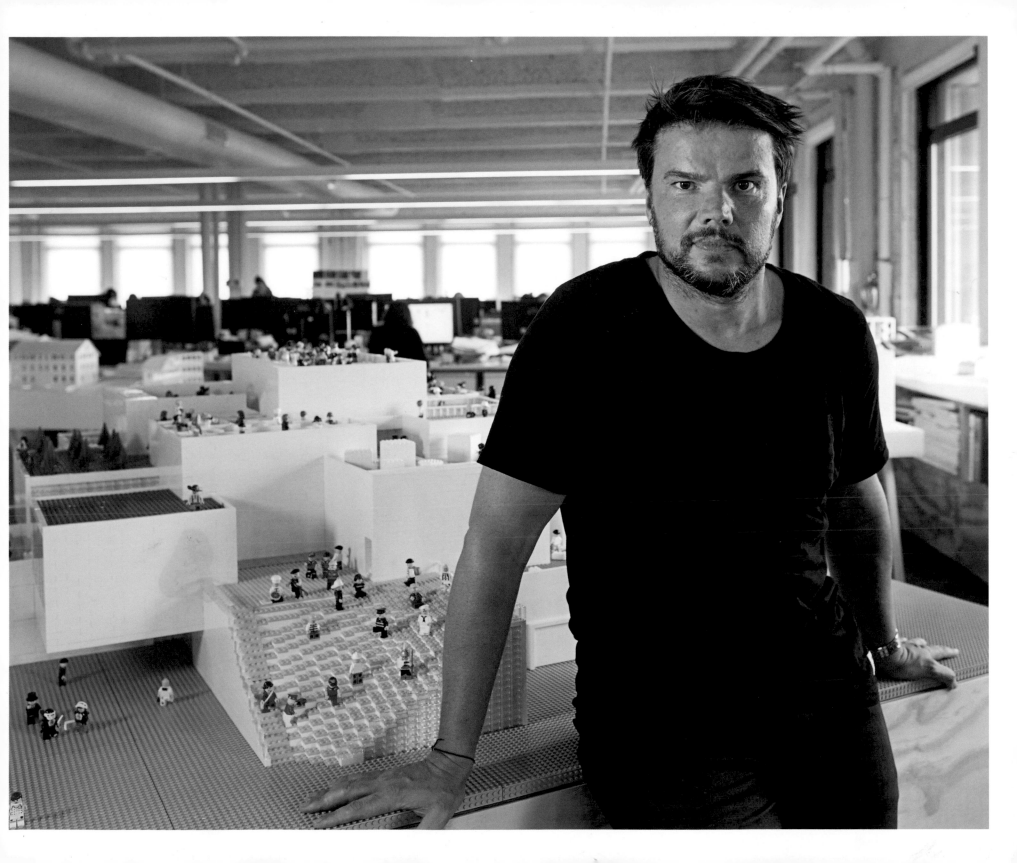

complete sense: Billund saw the LEGO Group transform from humble wooden toy shop in 1932 to today's multinational corporation, and with that, the town itself transformed from a little village to a prosperous city with its own international airport. Placing the LEGO House at the center of the city seemed logical.

The location shaped the building itself too. Since the LEGO House was going to rise in place of Billund's former town hall, Ingels thought that the Home of the Brick should be public in nature. He envisioned a building with free public playgrounds on its terraces and a gigantic central space featuring a coffee shop, two restaurants, and a town square in which guests and Billund citizens could hang out whenever they wanted. While this grand idea looked amazing on paper, and it was one of the reasons that made Kristiansen fall in love with the architectural project, it became a tremendously expensive proposition. There are no columns that hold the blocks that appear to float around the hall. To achieve that

effect, the hall is built like a bridge, with gargantuan steel beams that go from one corner to the other to support the weight of the twenty-one bricks that make the LEGO House. In fact, this amazing engineering feat pushed back the opening of the building because they had to use twice as much steel than expected. At one point, columns were proposed to solve the engineering problem, but Kristiansen was adamant: He didn't want to lose this open space.

The initial building's plan called for more than 21,000 square feet (1,950 square meters), but that almost doubled to nearly 40,000 square feet (12,000 sq m) by the time the project design phase ended. Despite this, the design didn't change much from Ingels's twenty-one-brick LEGO model. In one of those magic moments in which everything clicks, those interlocking spaces were all that the experience and interior design teams felt that they needed. Ingels didn't need to add another brick.

Opposite, top left: The topping out ceremony was held on October 8, 2015. A giant LEGO keystone locked all of LEGO House's other "bricks" in place.

Top right: The original plan was for the blocks to be self-supporting. When engineers realized this wouldn't work, the building's structure was redesigned, with the blocks mounted on a gigantic steel bridge.

Bottom right: LEGO House, during construction.

Bottom left: The craftsmen building the furniture for LEGO House invented a specifically designed trowel, perfectly shaped for the task.

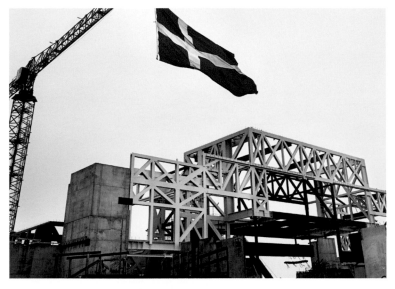

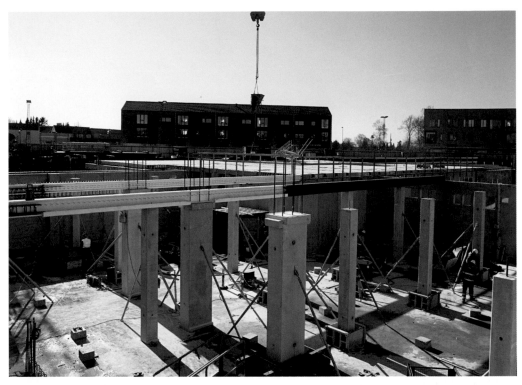

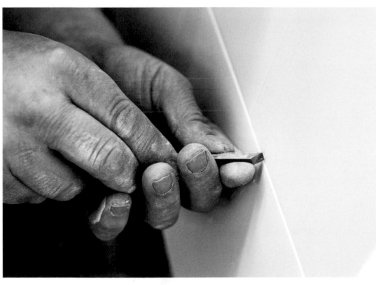

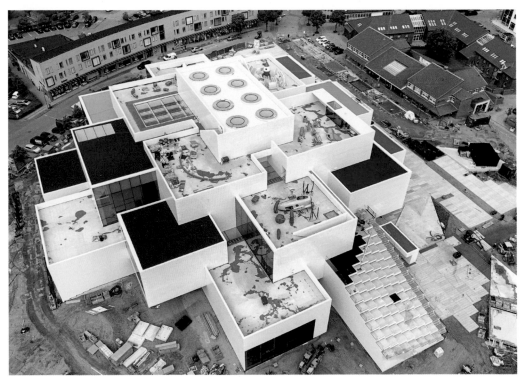

SOCIAL

COGNITIVE

EMOTIONAL

CREATIVE

SEVEN PRINCIPLES OF DESIGN

1:

Mike Ganderton, head of experience development at the LEGO® House, recalls that "the stars started to align" when the LEGO Foundation people came to the project table with their Learning Through Play philosophy. The design team realized that, if they took these five development competencies—social, cognitive, emotional, creative, and physical—and used them as the footprint for the house, they could make everything work. "The plans for the house were very similar to the first drawing that Bjarke Ingels created, the twenty-one blocks," Ganderton says. The outdoor areas—the playgrounds placed on the building's open terraces where anyone could play, even without a ticket—focus on physical competence. Inside, the team categorized the blocks into social, cognitive, emotional, and creative zones.

This zoning based on competencies became the first of seven principles of design that the LEGO House team used to focus the creative process. It was important to the design team to create boundaries to make sure everything clicked. "You could have imagined a

situation in which we created the ultimate LEGO play experience," Ganderton said. "I'm sure it would have been fun, but it wouldn't have an impact. People would come, be entertained, and leave." It had to be a lot more than a fun house, and that's why they created their own set of rules to make their design coherent.

Søren Hansen, the LEGO House experience development manager, and Rikke Ranch Høgstrup, the LEGO House senior experience designer, were in charge of making sure that this zoning was obvious to every guest. Both came into the project from the LEGO retail design team and then became involved in designing the internal space, working to incorporate LEGO DNA into the furnishings, the signage, and even the sound design.

To clearly signify the zoning, they looked at the four colors Ingels used in the building's exterior: green became the social competence zone, blue marked the cognitive area, yellow was used for emotion, and red focused on creativity. The physical competence playgrounds didn't have a dedicated color, but instead complemented each of the four zones.

Opposite: Four iconic LEGO colors were assigned to the four core competencies to create a clear visual language within the house.

Following spreads: The outdoor terraces are home to the fifth core competency— physical activity. The playgrounds follow a storyline that brings guests on a journey around the world.

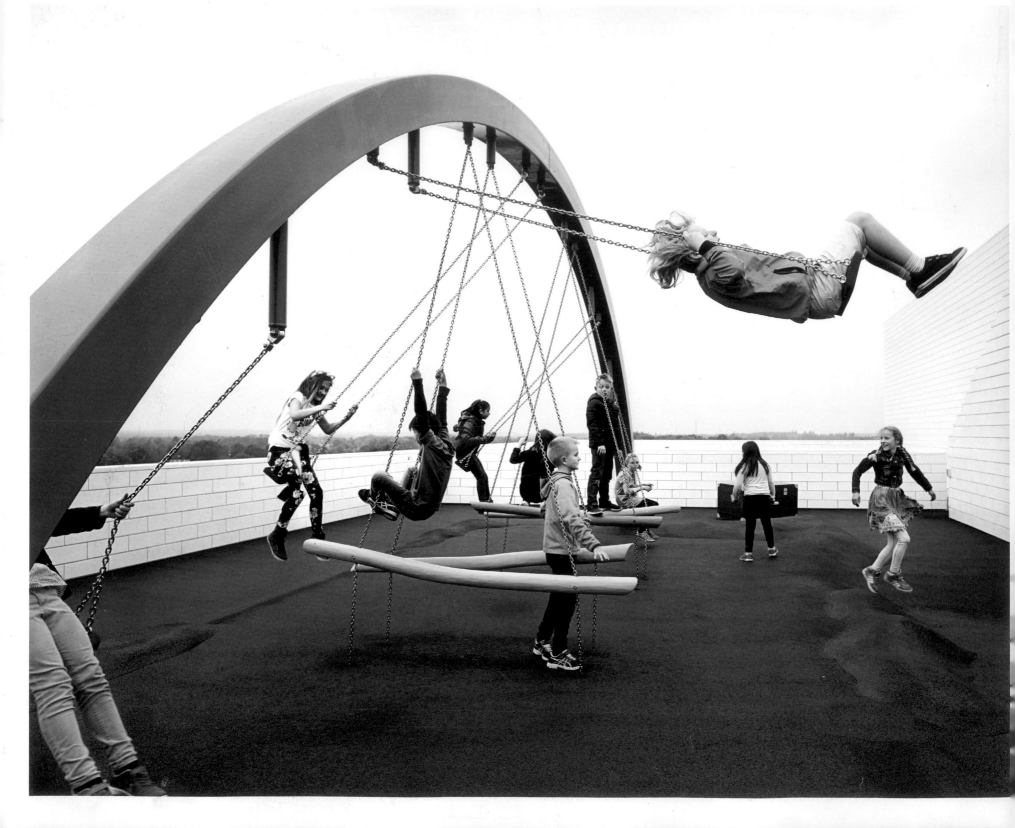

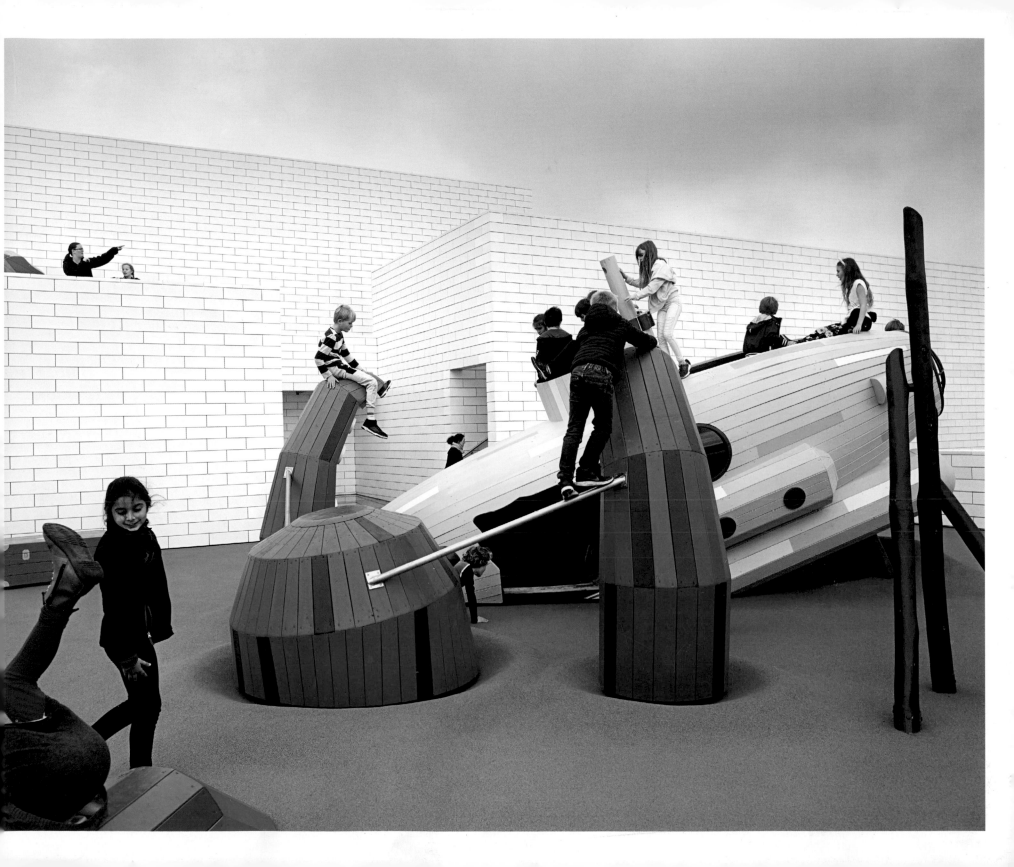

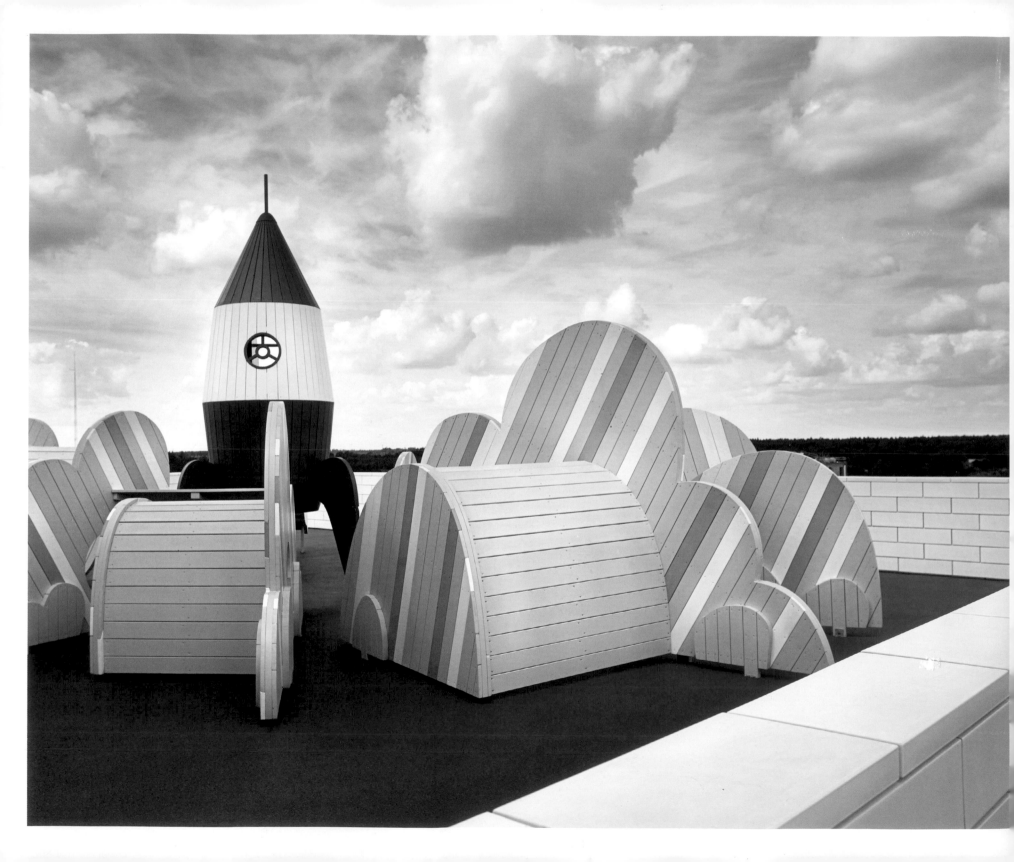

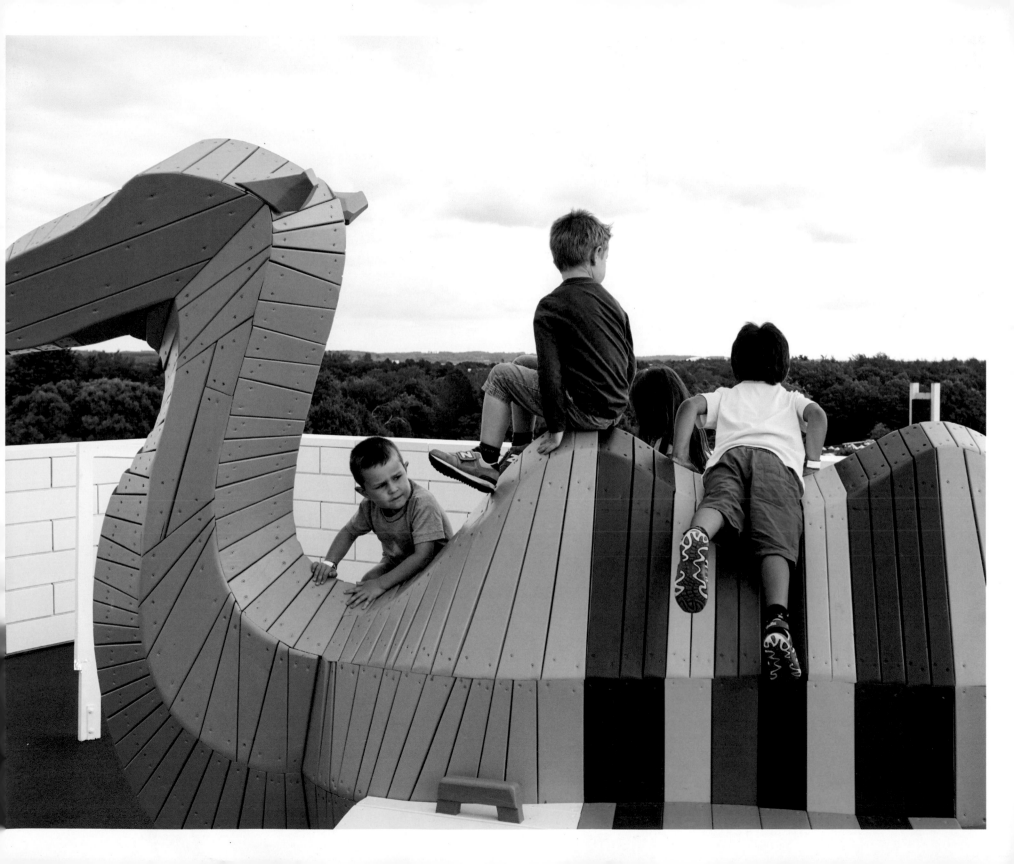

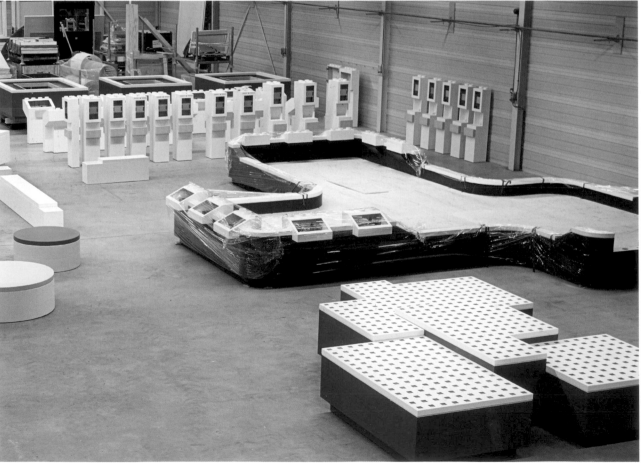

All of the furniture in LEGO House is modelled on the LEGO brick. The design team could simply empty out a box of bricks and start building custom, functional furniture for each part of LEGO House.

Everything Is Connected

"BIG made the building, but it didn't design the interior," LEGO House senior experience designer Rikke Ranch Høgstrup recalls. The LEGO House design team worked with BIG, contractors, and manufacturers to design the space and every piece of furniture it needed. They wanted to make sure that the outside and the inside were made with the same playful concept. The experience should be seamless, rather than a jarring contrast between exterior and interior.

The design team interpreted the building that Ingels had made and extended the concepts into every aspect of the LEGO House. For example, they looked at the tiles that Ingels had used in the design. These ceramic tiles covered the building's exterior walls and parts of the interior to make it look as if they were made with 2x4 bricks that had been enlarged at a 1:18.75 scale. Høgstrup and experience development manager Søren Hansen took that scale and thought: "What if we take the same scale and use that to design our furniture?" Luckily, as Høgstrup pointed out, that resulted in furniture that was actually usable by humans.

Following that line of thought, they realized that, if this building was going to be the Home of the Brick, it should feel as if it was made of bricks too. Everything—from the seats to the shelves holding LEGO models to the pools of LEGO bricks used in each experience—looks to be made with 1:18.75-scale LEGO pieces. Even the material used in these elements—called Kerrock—aligns with the idea of making everything look and feel as though it were made out of LEGO bricks. Kerrock is a brand of a substance called Corian, which is a solid, very hard material invented by DuPont. It's a polymer made of cement and resin that is a single color all the way through. It feels a lot like how a LEGO brick would feel if it were gigantic—cold, hard, and extremely durable. If you break a corner, you can glue it back, sand it, and you won't see the joint. And while they could have used any other material and painted it, that would have look okay for only a few weeks. Kerrock looks fantastic even after many years.

Sound design is a crucial part of the LEGO House too, completing the overall atmosphere. While a regular museum rarely uses sound to immerse guests in the experience, the team at the LEGO House believed that sound was going to be crucial. As Høgstrup explained, "We had a sound designer working on this full time with two interns helping him. It was a huge part of the design. Everywhere you go there are sounds that match what you are seeing. Just in the World Explorer—three vast islands made of 1.9 million bricks—there are 128 simultaneous soundtracks, with 65 tracks used to change the mood as the world transitions from day to night."

Every aspect of the interior design converges to make the guests feel at home. "It's the Home of the Brick and you are coming in as a guests," Høgstrup said, "but it's also your home." The team wanted people to feel that they are welcome. "Visiting LEGO House is not just about interacting with the activities in each zone," Hansen said. "The interior space is an experience itself."

RAL 260 30 30

C 8264 RAL 5017
NCS S 2065-R90B

C 8258-2 RAL 230 60 40
NCS S 1565-B

C 8282
RAL 040 40 67

8261 RAL 3020
NCS S 1085-Y90R

8252
NCS 0580-Y80R [OUD]

C 8253 RAL 075 70 70

C 8283 RAL 1021/1023

C 8254 NCS S 0550-Y

8255
RAL 150 40 50

8263 RAL 60 29
NCS S 2570-G20Y

82 56
RAL 130 60 60

RAL 9005

RAL 9010

The sound team tested many different designs to create the aural atmosphere in LEGO House. In the end, they decided on the sound of a bag of LEGO bricks being emptied out onto the floor. They added a joyful melody on top and the LEGO House jingle was born.

2:

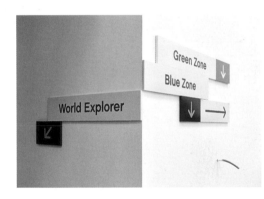

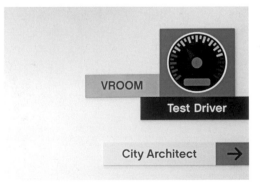

The second principle is free exploration. While you can follow something like the IKEA model, in which the visitor enters the building, follows a trail, and exits at the end of the maze, that doesn't work for play. In the LEGO® House journey, there is no pre-established path, just as there is no "right" way to play with LEGO bricks. They wanted people to find a motivation to discover side routes on their own—no one is going to tell you how to explore this place.

The interior design team thought about how to make a journey that is not forced but at the same time feels natural and isn't confusing. Areas are interconnected in such a way that people can start at the top of the LEGO House and take different paths to explore the surrounding zones. While there is no direction, there's an underlying design language of colors and graphic signage that codes the different zones and helps guests navigate their own path.

Throughout this division of space, the team used the connect-explore-transform matrix to lead guests toward their role in each experience. Each room has something spectacular that connects to the visitor by grabbing their attention. Then they make sure that each experience has something that the guest can see is fun right away, Hansen told me, which leads them through the exploration phase in which they build, and ends in a transform phase, where they reflect on their experience. This matrix repeats itself and becomes apparent in each room if you look for it, yet guests are never consciously aware of it.

The team also wanted to help unleash the guests' creativity by not making the LEGO House a walled linear experience. "What we did was to let [people] explore freely, but on the other hand, we were very focused in conveying what's happening in each zone and room," Hansen says. People can observe and easily understand through the colors,

signage, and experiences how the green zone is about social sharing or the yellow zone about emotional play, for example. As Ganderton told me me, the LEGO House is doing this job by itself, by design.

However, this nonlinear structure also introduced some operational challenges. Since designers didn't know exactly how people were going to explore the space, they didn't know whether guests would find all corners of the LEGO House, or how long it was going to take for them to explore it from top to bottom. They had a good idea about how it all was going to work, but they weren't certain. "But it was a choice we made, one of the principles we made to guide the design," Ganderton told me, "and you have to stick with that principle through the process of creation."

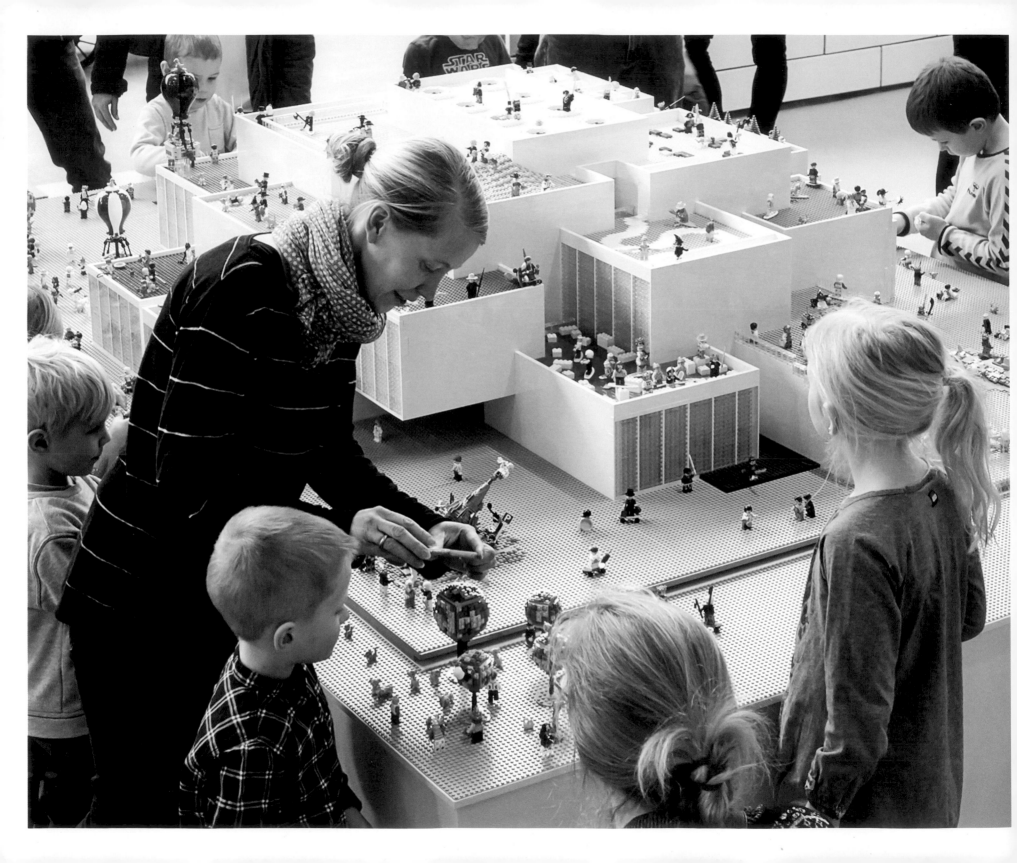

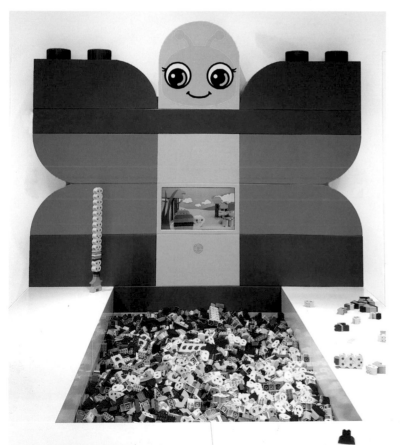

3:

The third principle dictated that the LEGO® House had to be extremely hands-on. The LEGO experience is about building with bricks, so the experiences had to be physical, even while some have digital elements, such as the Fish Designer or the Robo Lab. And there had to be LEGO bricks everywhere. Most people told the design team that this was a crazy idea: The bricks would end up scattered around, they would get dirty, people would steal them . . . but Kristiansen and everyone on the team were adamant: If the LEGO House was going to be the Home of the Brick, of course there had to be bricks everywhere available for everyone, children and adults alike. Not only that, but they had to be the shiniest bricks anywhere outside of a LEGO box. So when guests come in, kids can dive right into brick pools in the hall and the base of the Tree of Creativity. Throughout the LEGO House, no matter where a guest is sitting, it feels as if a bin of bricks is always within arm's reach. That way, even adults sitting down to relax will feel the urge to start playing. Even placing an order in the LEGO restaurant requires people to use colored bricks to ask for specific items, which are then digitally scanned and transferred to the kitchen for preparation by a conveyor belt. The magic pull of LEGO bricks is everywhere, just as the designers intended.

Squeaky Clean

According to head of experience development Mike Ganderton, the hands-on design principle will have operational consequences for as long as the LEGO House is standing. You can't eliminate the bricks from the design of the building, he said, and bricks inevitably get dirty. They eventually scratch and lose their shine as they rub against each other, so they are recycled into raw plastic material that can be used for things that don't require premium ABS plastic, such as planting pots.

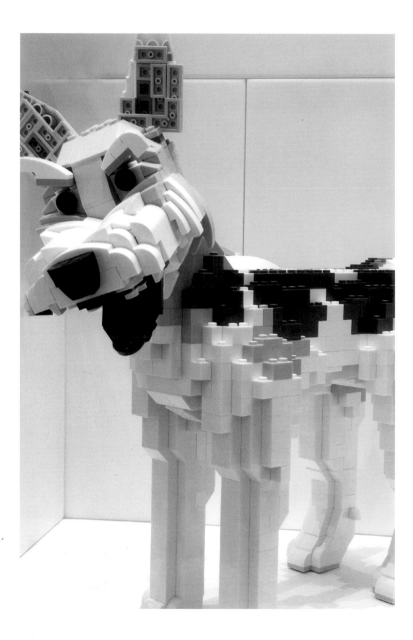

4: The fourth principle is that the LEGO® House shouldn't heavily feature franchises. The experience and design had to have a primary focus on core classic LEGO bricks, the basic elements that require pure imagination to take shape. There are two reasons for this. First, the franchises change very quickly. Since it isn't possible to know how long something is going to last or when the next movie is going to peak, featuring franchises could make experiences feel obsolete.

The second reason is that scripted stories from franchises can distract from the experiences themselves. An exception to this rule is in the World Explorer experience, where Harris and his model-building team use franchises such as Superman or Batman to make jokes. From time to time there are temporary exhibitions or creative experiences with a franchise as a starting point, but classic bricks take center stage in most of LEGO House.

5: The fifth principle of design is that there are no building instructions in the LEGO House. There are clues. There is inspiration all around you, in the building itself or other guests as they go through the experiences. And there are Play Agents, facilitators who guide play dynamics in each room. But nobody will tell you what to do. There are no high scores. There are no measurements to stand against. While the ultimate prize might be to have your models showcased in Masterpiece Gallery, the Learning Through Play process allows each guest to feel successful in a different, unique way.

Top: A palette of familiar LEGO colors, realized in large scale.

Bottom: The Test Driver experience located in the Blue Zone is built for collaboration and friendly competition. No building instructions needed.

Play Agents

While there are no instructions in the LEGO House and nobody will tell you what to do, there are people always ready to make things easy for guests. They are called Play Agents and they are an integral part of the experience, according to the LEGO Foundation's research manager Tina Holm.

These Play Agents, who come from many backgrounds and receive play facilitation training at the LEGO House, gently engage with guests as they explore. The Play Agents can identify someone who is having a problem figuring something out or just interact with a group of children to enhance their experience.

They are one of the LEGO House's strategic pillars, according to Jesper Vilstrup, managing director of LEGO House, which is why the organization has invested heavily in them from the start. During their recruitment, human resources specialists evaluate each person's mind-set and their capacity to engage with guests, which is more important to them than their CV. When hired, each Play Agent spends a long time training to understand the full culture of the LEGO House, from hospitality and guest services to the very core of what Learning Through Play means for guests.

6:

The sixth principle of design establishes that each experience should be accomplished in twenty minutes.

At the beginning, the design team really didn't have any idea of how long the experiences should be. They spoke with many people in the museum industry. It's a world that, as they found out, is very open and likes to share their know-how. Experts explained that there is a limit for how long people will stay in an indoor museum, which is intimately related to the way humans work. It seems that, no matter how much we like a topic, our attention span is limited because we get tired of things even if we like them a lot. If you are a big Picasso fan and go to a museum solely dedicated to Picasso, you will love the first painting. After the first dozen, you will start experiencing some fatigue, which may ease momentarily in front of a particularly great work. But after seeing one hundred Picasso paintings, you will be saturated. There's no way you will enjoy the hundredth painting as much as you liked the first or the tenth. According to the experiential data from museums all over the world, this limit to our attentive enjoyment is typically three to four hours.

As a result, the design team focused on creating a fantastic three- to four-hour experience so guests can leave feeling satisfied that they had the full experience. Since there are fifteen different spaces available for the four-hour experience, the team calculated that visitors should spend sixteen minutes (which they rounded up to twenty minutes) in each space. If guests are inspired to move to the next experience after twenty minutes, they would be able to see all the dimensions of Learning Through Play that the team wanted to showcase without getting burnt out on bricks. In each experience the team incorporated "natural jump points," events that make guests feel okay to wrap up and go to the next experience in sight.

Nevertheless, after they opened the doors, the design and operations teams discovered that people actually spend more time in the LEGO® House than expected. According to managing director Jesper Vilstrup, while they thought that visitors would probably spend between three and a half and four hours in the LEGO House, the reality is that guests spend from seven to eight hours. That doesn't mean that they are in the experiences nonstop. The reality is that visitors divide their day, spending some hours in the experiences, then have lunch at the cafe, then come back to the experiences, go outside to the playgrounds if the weather is good, and then go to the retail store (which, incidentally, is not placed at the end of the LEGO House as in most museums, but is an open shop located in the public town hall). So in reality, while guests may be spending about four hours on the experiences themselves, the fact is that they spend from seven to eight hours total in the LEGO House.

7:

And finally, the seventh principle of design and the one to rule them all: Learning Through Play. As we have already explored, in this learning model a learner goes from the connect phase to the explore phase to the transform phase. The LEGO® House design team adopted this philosophy from the LEGO Foundation and divided each phase into three different steps, resulting in a nine-step journey for every room.

In the **connect phase**, guests find a reason why they should do something, why *they* want to learn about this or play this way. This begins with a *"wow" moment*. As Ganderton described it, if a teacher stands next to a whiteboard and says, "You need to learn *this*," chances are that most people will yawn and not show any interest. But, if the teacher brings a specimen from the forest and says, "Come close and look at this, but don't get your fingers too close because it will probably bite you," students will likely jump off their seats to get close and ask questions about it. That *"wow"*

moment is what an educator—or in this case an experience—uses to connect with people's curiosity, what makes people want to play. You can clearly see this in the World Explorer experience, three colossal islands with thousands of lively vignettes. The scale and complexity are so vast that anyone who sees it literally says "wow," with their jaws dropping to the floor. The Fish Designer experience, with its massive tank and the Robo Lab's impressive flowers and bees, inspire the same reaction.

When people move closer, they have an *"Oh, I get it" moment*. This is when guests engage with the pool of bricks at the bottom of a massive waterfall (the *wow*) and start building right away.

The third step of the connection phase is the *understanding my role moment*. Guests see how they fit into the structure of the experience. In the Fish Designer experience, they understand that they are supposed to add a fish to the tank. "We try to make [the

realization] as quick as possible, so guests understand how they fit into it," Ganderton told me. "A big part of that is seeing other guests doing it. That's something we learned from the museum industry too, that the best way to involve people is that they learn from other people." Relating to other guests also gives guests a safe environment to try new things.

After the connect phase is the **explore phase**. The first stop here is the *first fun moment*, something that motivates the guest to keep trying. This includes a little success early in the journey—so the guest can realize, "Oh, I see where this leads to" and it's not impossible to get there. After that comes the most intense step: the *immersion moment*, where people really lose themselves in the experience, thinking, assembling, testing, and iterating. After a while, this experimental process leads to the *"aha!" moment*. In the Test Driver experience, for example, people see how the geometry and distribution of the bricks and wheels will make a car go in a straight line or break into dozens of pieces after a jump.

In the **transform phase**, guests get to the *end point moment* around the twenty-minute mark, where they think, "Oh yes, I've accomplished the challenge." From there they can either do it again or think, "I've done this, I want try the next thing ahead." When someone—a parent, a sibling, or a Play Agent—asks guests to explain what they did in their own words, the answer is the *lasting impression moment*. People do this internally too, instinctively, and it sticks with them. And finally, there's the *sharing moment*: Everywhere in the LEGO House there are small kiosks equipped with cameras that allow guests to capture what happened and then share it thanks to the digital wristband that every guest has. In the classroom, this moment is the equivalent of the show-and-tell.

The Wristband

The guest's digital wristband is a very popular element of the LEGO House experience. It contains a unique identifier that is associated with each guest. The identifier can be transmitted to the camera-equipped kiosks that are located all through the LEGO House, next to each experience. Near-field communication—a wireless protocol—transmits the guest's ID to the kiosk, allowing a person to take photos of whatever they have been working on or to log achievements. These mementos get *automagically* uploaded to the cloud, which can then be downloaded from the LEGO House website.

But, like everything in the LEGO House, the wristband actually plays a vital role in the Learning Through Play process. That collection of mementos is important! They help guests reflect on what they built and experienced in the LEGO House. When they get home and download all the stuff from their trip is when they can reflect and share with others, extending the LEGO House experience at the same time.

According to Mads Mommsen, the LEGO House's digital lead, another part of the wristband is that it enables guests to run around and play without having to take their phones out all the time. The wristband effectively gives you mental space to focus on play and creativity, and to be with the people you are with rather than getting lost in social media. And since they integrate taking photos and videos into the experience themselves, it becomes part of the entire LEGO House experience in an organic way.

This was made by design, because guests need both hands to be able to build with bricks. "When we talked about digital, we said we wouldn't want third-party devices like phones. They get in the middle," Mommsen said during a phone interview. The design team realized that there couldn't be any experience where you are required to use your phone or tablet, but at the same time knew that people would like to take photos and keep memories. That's when they came up with the idea of installing capture stations and using the RFID (Radio Frequency Identification) wristbands to enable it. Not only that, but since the kiosks are in a public area, the process of capturing the memory turns into a social activity that you can do together with others, bringing guests together around a public point. The digital layer, rather than separating guests, acts as a social layer too.

The team applied this nine-step journey to the design of every experience and used it to measure their success too. During the experience design testing, they would notice that perhaps the *"wow" moment* wasn't impressive enough, so they would tweak it accordingly. They also fine-tuned the steps to heighten the really important ones, such as the immersion or sharing moments. One example: In the Robo Lab, guests craft a line of code using icons to give instructions to a MINDSTORMS® robot. When they press play, the robot begins to move and, every time, guests look at each other and say, "Wow, did you see that?"

When the team found a moment like that, they would latch on to it and power it up to hook people into the experience. Other times, however, they would find that people's attention would drift, which required the LEGO House designers to fine-tune that particular moment.

"We use this nine-step tool to interrogate ourselves about all the designs," Ganderton explained. "We still use this tool when we develop new things, even things that are not related to the play experience. It's a useful tool to design our narratives."

THE DESIGN PROCESS

After these principles were set in stone, the job of the design team was to create some amazing play experiences for each of the zones. To kick things off, they held ideation workshops with the help of some external designers who knew the LEGO® universe. They also invited freelancers who roughly knew what the LEGO brand was about but as outsiders weren't bound by as many preconceived ideas.

During these ideation sessions, participants would come up with ideas and present them to the rest of the group. The group would then build on these ideas, saying things like, "I love that; what if we could add a bit of this or twist that or add this dimension to it?" They never said no outright to anything, but the biggest and best ideas rose to the top organically.

Through this process, the team refined the idea for City Architect, an experience where people can assemble a city by putting blocks with different functions together. The process follows the same principles as building a real city. The Story Lab, which allows guests to use stop motion to make short movies, was an early idea too.

After this development phase, the design team would bring the best ideas to the design board, which was the LEGO House's guiding group, led by Kjeld Kirk Kristiansen and Jørgen Vig Knudstorp, chairman of the LEGO Brand Group. At the beginning, the team tried to sell the board on concepts alone but soon learned that most people can't work with concepts. This led to another phase of the ideation process:

They needed to visualize the ideas by making artistic mock-ups, physical scale models, and even hands-on prototypes. Ganderton explained that the team ultimately built an entire scale model of the LEGO House, and once they were able to establish how the rooms would look, they were better able to guide the board on what the experiences would be.

It took longer than expected, but it also gave the design team much more useful feedback from the stakeholders—and eventually from children when they were testing prototypes with them. That's how the project moved forward. This process became a mantra for the team: "Make It Real World."

Designing LEGO House was the collaborative work of many dedicated teams. Mockups of the individual experiences were—of course—built in LEGO bricks!

Left: A detailed model for Fish Designer in the Yellow Zone.

Following spread: Models for Brick Builder in the Red Zone, Character Creator in the Green Zone, the BRICKACCINO Café, and the central staircase.

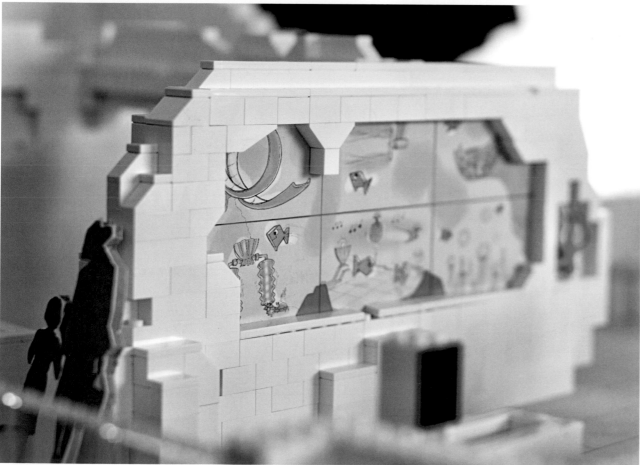

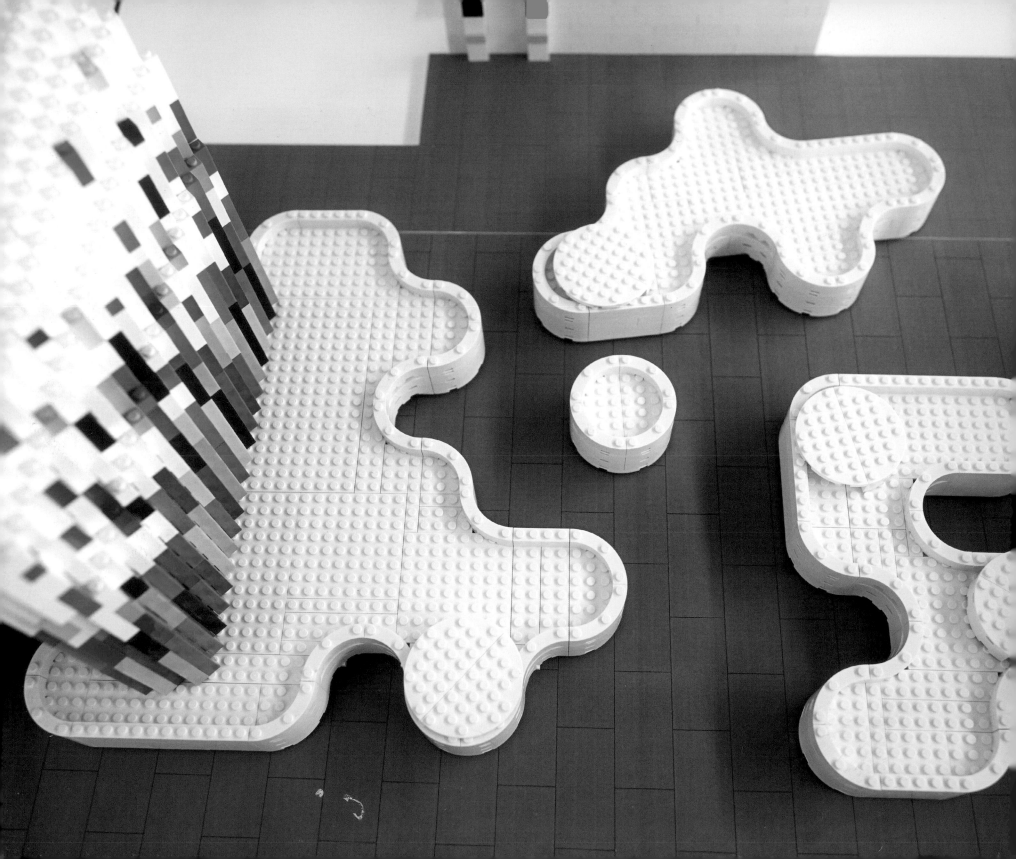

Making It Too Real

The "Making It Real World" mantra initially brought some problems. According to Mads Mommsen, the LEGO House's digital lead, their first project taught them a lot about how much reality is enough and what is too much: "City Architect was the first experience [we worked on] and it became a really iterative process that started very, very simple but, by the time we tested it out, we had created a huge setup with a big investment, just for the testing of prototypes." They had invested a lot of time and money into making the early prototype absolutely perfect, and then the results just weren't as expected. "We needed to start thinking differently," he said. "We needed to work simply and accept the fact that we could use prototypes and mock-ups that looked horrible or didn't have too much detail to test functionality."

After the early development issues with City Architect, the team decided to focus the design of the next experience on playability first, leaving the final aesthetics for later. It was a success. The first prototype gave them enough results to iterate and refine for the next day. And then again. And again. After that, everything changed. This was their very own Learning Through Play process, and the team came out transformed. "What was important was not the beauty of the experience," Mommsen and the rest of the team realized. "As long as you had the core playability down, it could be pulled off in many ways and kids can really enjoy that." This made it possible to move fast without a huge investment up front, which in turn made it possible to execute the LEGO House experiences on time.

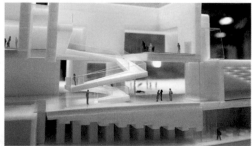

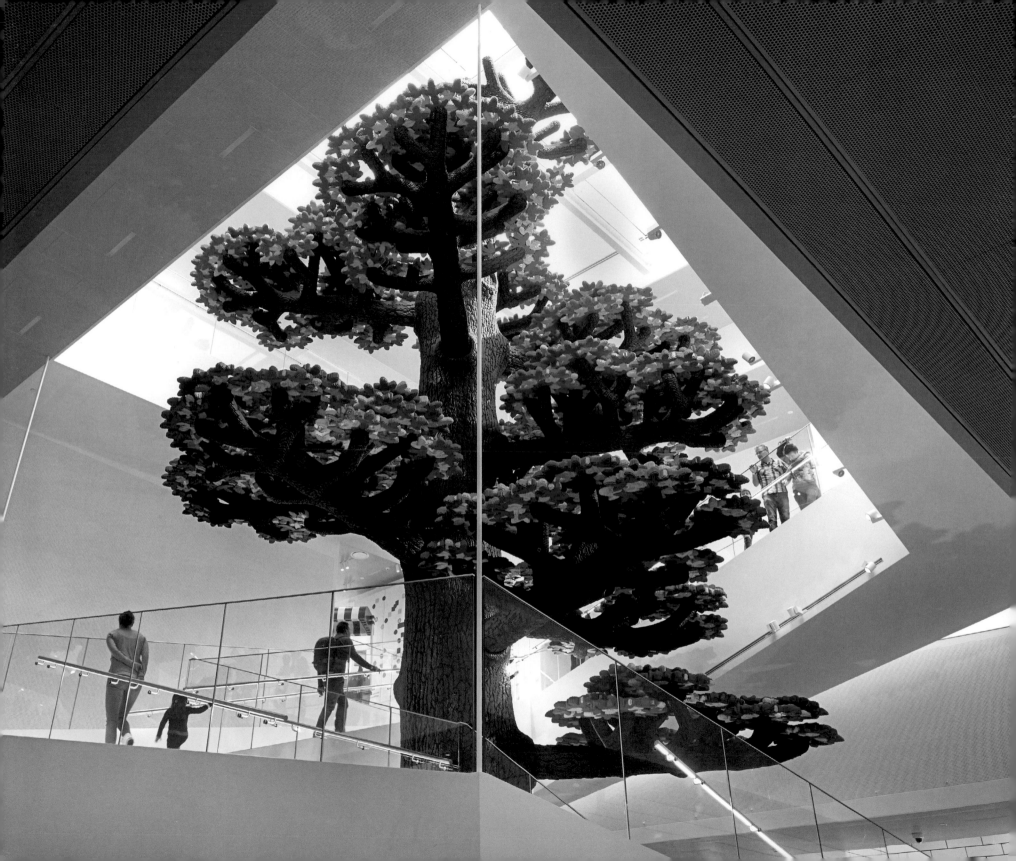

IMMERSION.
Exploring the LEGO® House.

Architect Bjarke Ingels's original twenty-one-brick structure remained unchanged throughout the interior- and experience-design process, but the design team did introduce some modifications to make everything click with the Home of the Brick. One example of this was in the design of the History Collection, the secret vault–style room full of old sets like the one I'd experienced on my first trip to Billund, only on a much larger scale.

Another addition was the central staircase that takes guests all the way to the top of the building, and serves as a fitting starting point for any exploration journey into the LEGO® House. The stairs were not in the original plan of the house, but the LEGO House needed an epic "wow" moment to invite guests into the exhibition areas. The team envisioned something like New York's Guggenheim Museum designed by Frank Lloyd Wright, in which people walk all the way up to the top of the museum and, from there, comfortably visit all the zones on their descent.

Given the size of the interior hall, BIG came up with the idea of a grand staircase with a very large space in the middle. The design team thought that such a grand space needed to be filled with a grand model, one that would be both a "wow" moment inviting every visitor to explore, and a representation of the LEGO brand itself.

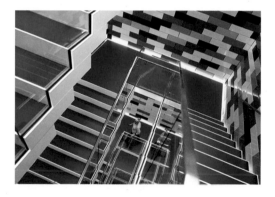

The central staircase guides guests through the house at their own pace.

Opposite: the Tree of Creativity is not only the center of LEGO House, but it is one of the biggest LEGO models ever built.

THE TREE OF CREATIVITY

Stuart Harris, senior experience designer at the LEGO® House and the lead designer for all the models inside, started to brainstorm ideas for the staircase model in December 2013. According to Harris, who has a long history designing LEGO models since he joined LEGOLAND® Windsor as a builder in 1993, the model design team was already thinking about a tree by January. "We explored lots of different avenues, but we kept coming back to the tree, because the tree ticked a lot of boxes," he told me while describing the massive endeavor. The tree was a great iconic object. It could conveniently fill the large and weird architectural space of the stairs because you can put branches wherever you need. And, most important, it was a model that they could use as a storytelling device.

They called it the Tree of Creativity, and it is one of the biggest LEGO models ever made, at 51.4 feet (15.68 meters) in height, made out of 6,316,611 bricks with a total weight of 20 tons (18 tonnes). "We joke with the kids, saying that if you look into the 2017 catalog you won't find any green or brown bricks because we used them all here," Harris told me. "It's not true, but it's a nice story." The company had an army of model builders working in three shifts, twenty-four hours a day, to build the Tree of Creativity. It is so gigantic that it took 24,350 man-hours to assemble, plus 1,200 man-hours to install. In fact, the Play Agents tell children who are seven years old that, if they started to build the tree by themselves using all the days in a year, they would be nineteen by the time they finished.

For Harris, the Tree of Creativity fit naturally into the story they wanted to tell about the LEGO brand. First, it honors the heritage of wooden toys: On the base there is a carved duck just like the original iconic wooden duck, plus the famous wooden LEGO fire truck and tractor. It also has a tribute to the different generations of owners carved onto the tree: OKK, GKC, and Kjeld. Three-quarters of the way up the tree there's a woodpecker carving the letter *T* on the tree, which actually was Kjeld's idea. The *T* stands for Thomas Kirk Kristiansen, who became deputy chairman of the LEGO Brand Group in 2016. "We were in a transition period where Kjeld's son will be the most active owner," Harris told me, "and so we wanted to reference that transition."

As guests climb the stairs, they discover the tree's thirteen branches, some of them containing big LEGO vignettes. The team focused these scenes on the classic LEGO themes—Town, Castle, and Space—plus LEGO® Friends. According to Harris, they wanted to tell the story of these themes so the visitor could see their evolution as part of the story of the LEGO brand. The designers mixed different sets from these themes to create each vignette. For example, the LEGO® Space vignette contains the Galaxy Explorer alongside Benny's spaceship from THE LEGO®

MOVIE™ and the LEGO® Creator space shuttle. Some of those old models had to be bought in secret on eBay and other sites because the only sets the company had were securely stored in the LEGO Idea House's secret vault.

"We designed the tree so it could change over time," Harris told me. They are actually now building a new scene in their model shop in the Czech Republic, just west of Prague in a town called Kladno, where they build models for the LEGOLAND parks and shops around the world. That scene should be on the tree by the time this book gets printed.

To create the tree, Harris's team followed the same methodology used with every monumental model. They started with a very simple mood board image, then moved into some hand-drawn sketches, and then to a very simple computer model to fill the space in a 3D CAD schematic of the LEGO House. Doing that gave them an idea of the actual scale of the final tree model. From there they moved into their own proprietary LEGO 3D construction software, where the model shop started to develop the structure made of virtual bricks. "Even then, even when you place every brick in the CAD model, you still want to see something physical before you feel comfortable signing the model off to production," Harris pointed out. The way they did this was by making 10.7-square-foot (1-square-meter) sections of the bark, with different levels of detail, then comparing them side by side to see which direction felt the best.

In the end, the team opted for the most detailed version. "We said we have to go all in, we have to make it the most detailed thing," Harris recalled. "We wanted to have that kind of double take, in which you go, 'Oh, is that real?' from a distance. And then as you go closer and closer, [your] jaw should be dropping lower and lower as you start appreciating the scale of this." He is not kidding. The result is truly jaw-dropping. The Tree of Creativity looks like a weird old tree from a distance. It looks as if the tree were there first and they built the house around it, as Harris said. "It's very natural the way it grew from the first mood board drawing—it all fell so natural."

But then when you get to the top of the tree, you discover that it is actually made of bricks. Rather than completing it with a treetop, the team decided to make it obvious that it was made of LEGO bricks by building a faux construction site, with the iconic LEGO® Technic crane and minifigures posing as construction workers—the type of self-aware, self-referencing LEGO humor that is pervasive throughout the LEGO House. "It's also a metaphor for the LEGO Group," Harris points out, "a company that is continually evolving [its] organization, reinventing ourselves in terms of products and play."

As guests walk up the staircase, they soon discover details carved into the trunk of the tree. As the founder of the LEGO Group, Ole Kirk Kristiansen's initials (OKC) are carved near the base. Guests might also spot a duck, a fire truck, a cock, and a tractor, all iconic wooden toys from the company's early years.

Opposite: There are thirteen branches on the tree, all designed to support giant scenes inspired by each of the core LEGO play themes.

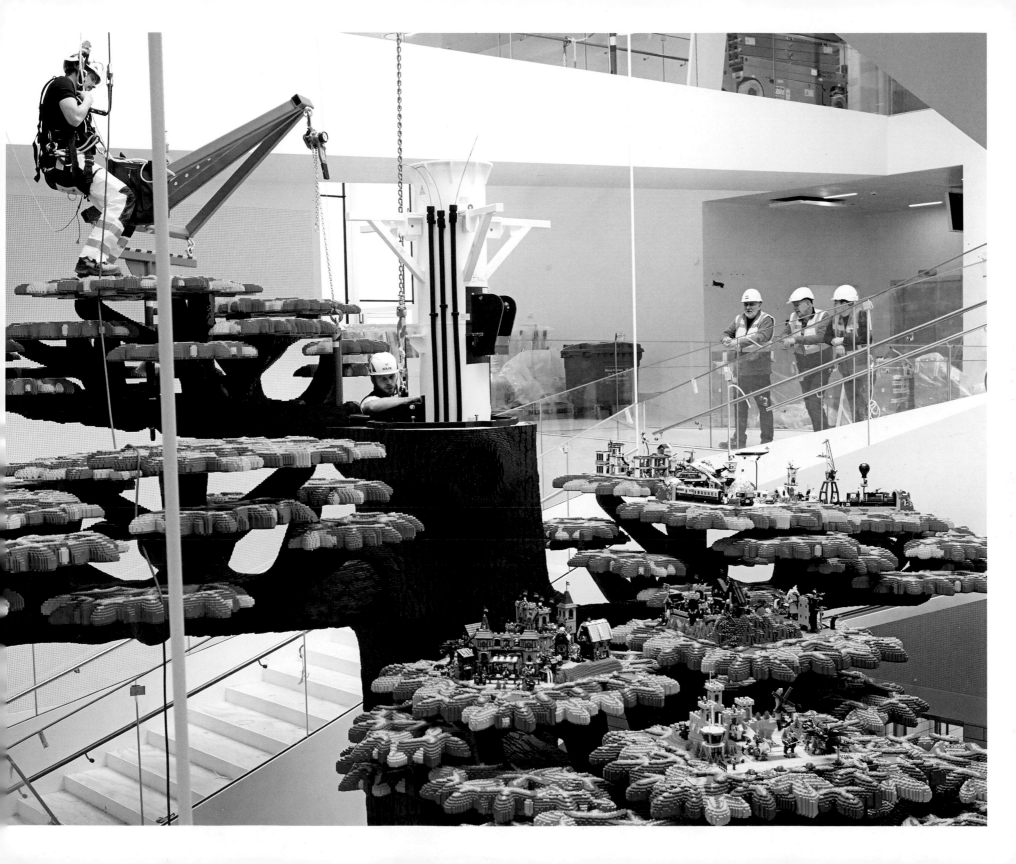

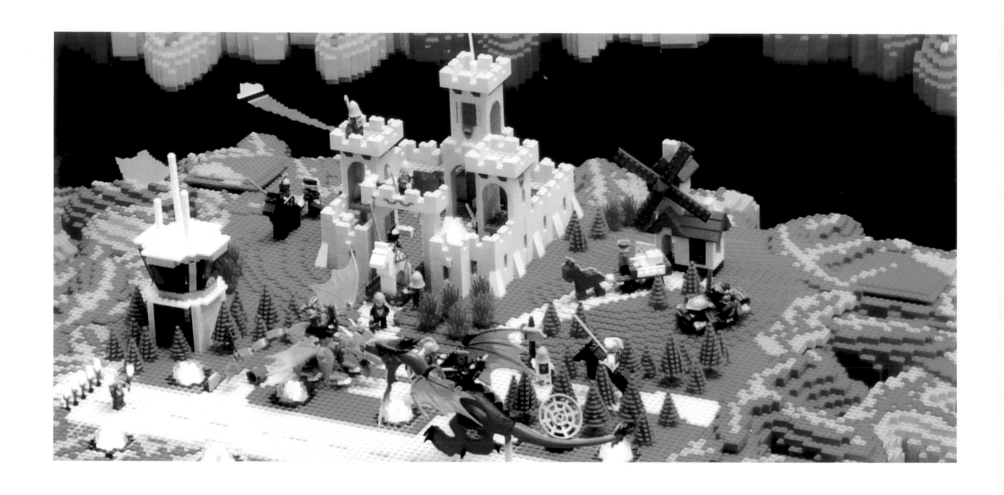

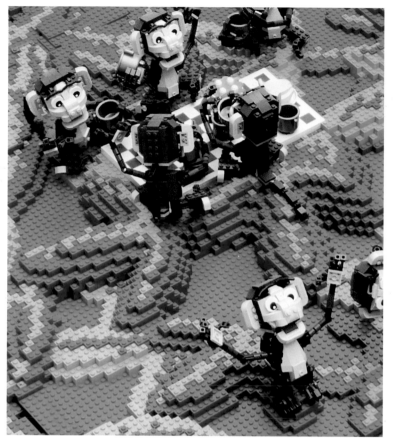

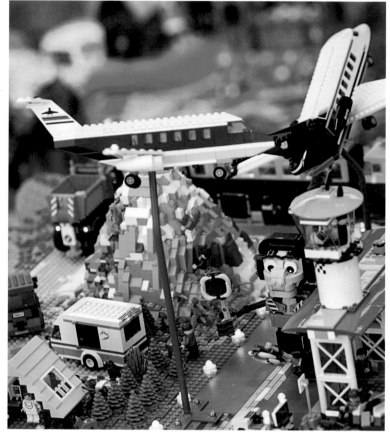

Above: There are fourteen monkeys playing roles throughout the tree's many scenes. Here a monkey regulates traffic on the LEGO City branch, which features the classic LEGO Airport Shuttle Monorail from 1990 and the legendary red passenger airplane from the LEGO Airport set, released in 1985.

Opposite: The LEGO Castle branch of the tree highlights the classic LEGOLAND Yellow Castle, originally released in 1978. The scene also offers a hidden joke: an airport for dragons.

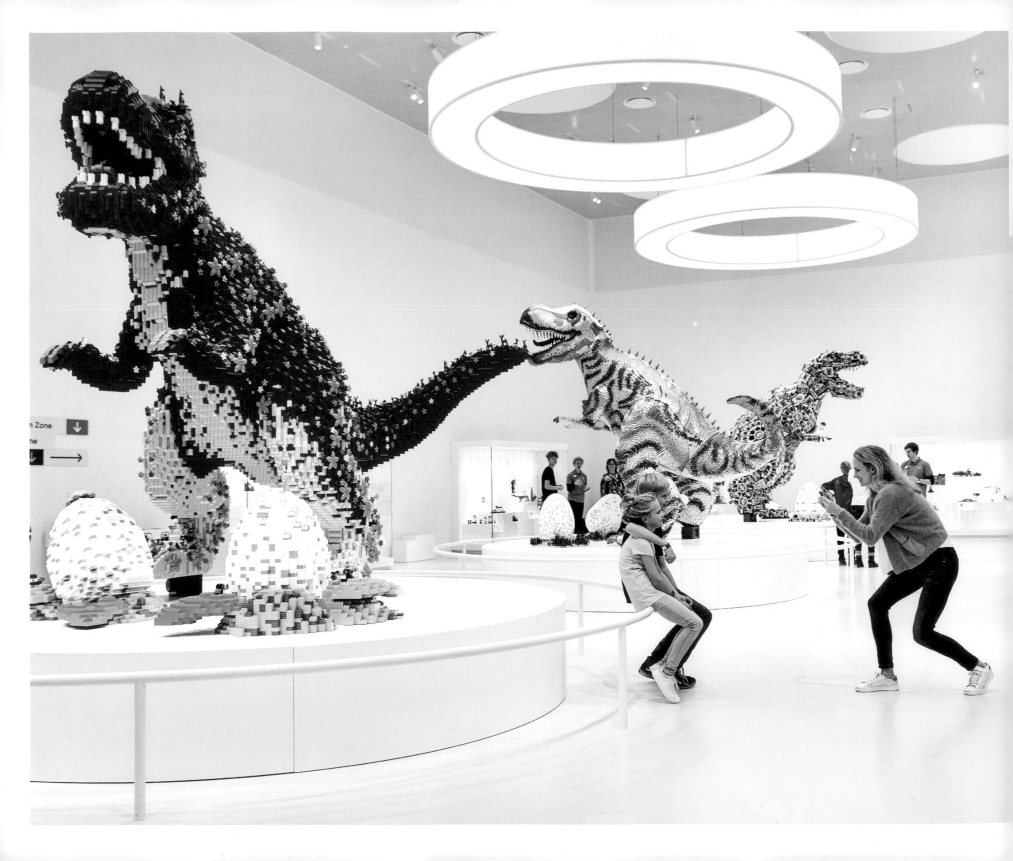

THE MASTERPIECE GALLERY

At the top of the staircase you will find yourself inside the 2x4 brick that an alien could spot from space. This is the Masterpiece Gallery, a large room where Harris and his team curate some of the best LEGO® models ever created by Adult Fans of LEGO (AFOLs) throughout the world. Kjeld Kirk Kristiansen is a huge fan of LEGO enthusiasts, going to LEGO fairs around the world to see the amazing constructions they come up with, from giant aircraft carriers to StarCrafts to cities and trains and everything you can imagine. "Having the fans involved from the beginning was a very passionate thing for Kjeld," Harris told me, "so this was a showcase for the fans and the creativity of the fan community. . . . We reach out to the LEGO Ambassador Network and we ask them to make nominations for the space. At the same time, if we see a fan's work that we think will fit great in the space, we ask him or her directly."

The Masterpiece Gallery is an enormous white room that reproduces the interior of an actual 2x4 brick. Ingels recalls the day the team invited some AFOLs to see the project plans, who suggested adding knobs to the ceiling, thereby turning an otherwise normal gallery into a giant 2x4 brick. Everyone thought it was a great idea. The architects turned the eight huge knobs on the scaled-up brick into glass skylights embossed with the LEGO logo to let natural light come in. People can climb to the roof and look down into the room as well. Two of the Masterpiece Gallery's walls are covered with glass-enclosed shelves that contain selected AFOL's models.

But the most impressive part is right at its center, where three giant podiums that correspond to the three tubes inside a 2x4 brick hold three dinosaurs made of LEGO bricks. They are impressive because they are huge, more than 10 feet (3 meters) in height. "Fans build big models but not necessarily tall models," Harris said. "We needed something with some elevation to fill the space." With the height requirements of the gallery space in mind, the design team decided to build their own. As the Masterpiece Gallery is meant to showcase the work of the fans, the design team worked with fan groups to get creative direction and input on how to execute the large-scale models.

Harris wrote a brief to explain the task at hand: "This is the Home of the Brick, so we really want to showcase the endless possibilities of the brick. We have three podiums, so let's use the three core systems: LEGO® DUPLO®, LEGO® System, and LEGO® Technic. If we are using these three systems and we build the same model, but using these different systems, how different can we make them?"

Brainstorming, the team decided to make a T. rex, each using one of the three types of LEGO bricks. After all, Harris points out, dinosaurs have been a LEGO theme over many years. They also are

greatly appealing to all genders, timeless, and easy to relate to. The brief, basically, was to build three dinosaurs in the three different systems that were each around 10 feet (3 meters) tall, he explained.

The team made an online private forum with twenty-six fans. They came up with some great ideas: everything from small details to the overall look and feel to the entire design approach.

Take the LEGO Technic T. rex. The LEGO Group had never done a model this big using LEGO Technic, so Harris and his team had no experience and no idea how to approach it. But one of the fans suggested doing it systematically: Develop eighteen different panel designs and use those to create a skin for the dinosaur by repeating them about seven hundred times. It came out really well. After that experience, the LEGO model shop has been using the same approach to build models of real things on a 1:1 scale, such as the Chiron car the company made for Bugatti.

For LEGO DUPLO, the fans suggested making something really fun, playful, and colorful. There are wonderful small details only seen upon close inspection, such as the DUPLO turtles used for the eyes and the excavators for claws.

The System T. rex, like the Tree of Creativity, was about getting as natural-istic and realistic as possible.

The results were three colossal half-ton (455 kilogram) dinosaurs: the 50,000-element DUPLO dinosaur, the 250,000-element System dinosaur, and the 250,000-element LEGO Technic dinosaur, all of them screaming in pain as they step on a humongous 1x1 LEGO brick made of Corian.

Right: The massive dinosaurs under construction in Masterpiece Gallery, next to their model counterparts.

Opposite: The Technicosaur and Systemosaur enjoy a summer popsicle. The details around the three dinosaurs can change throughout the year.

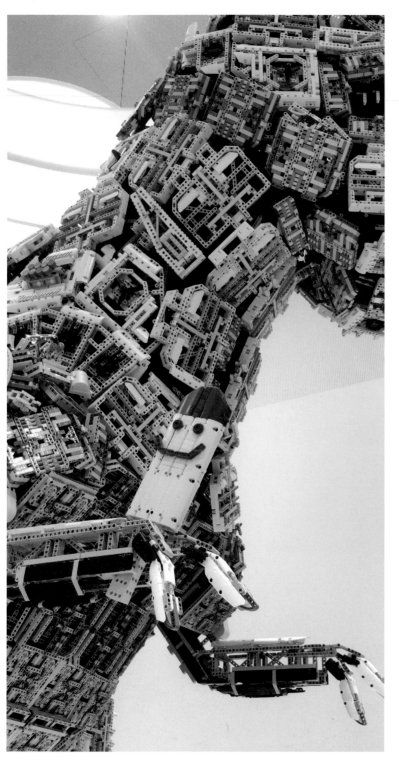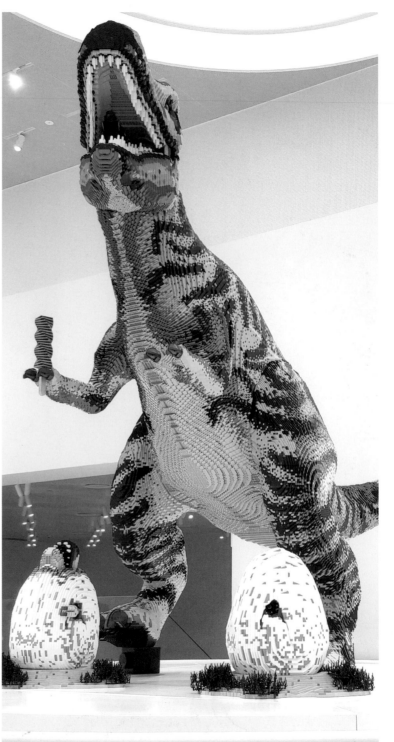

The Masterpiece Gallery showcases the creativity of master builders, LEGO fans with standout artistic sensibilities, amazing imagination, and top-notch building skills.

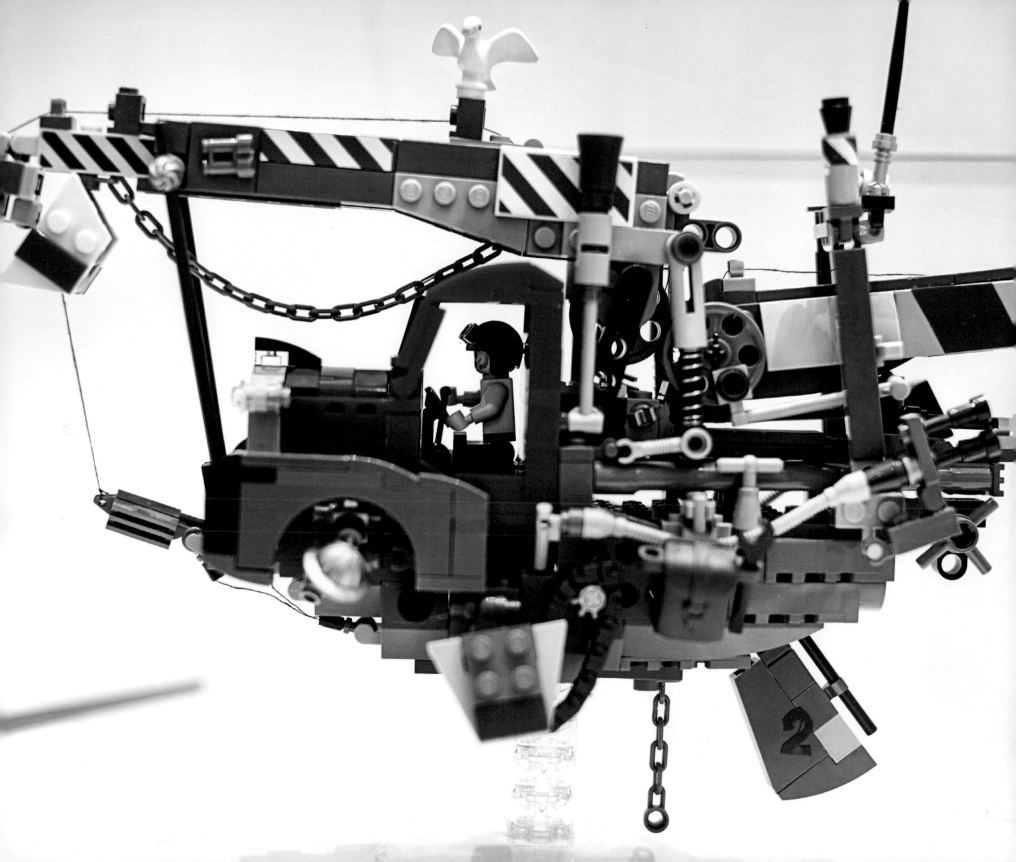

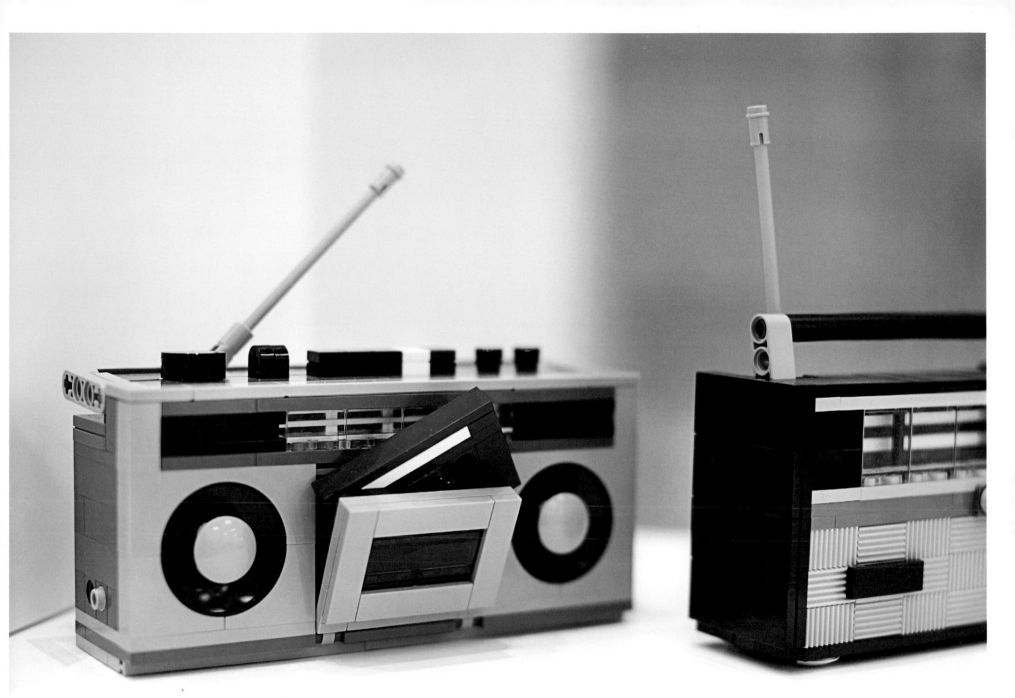

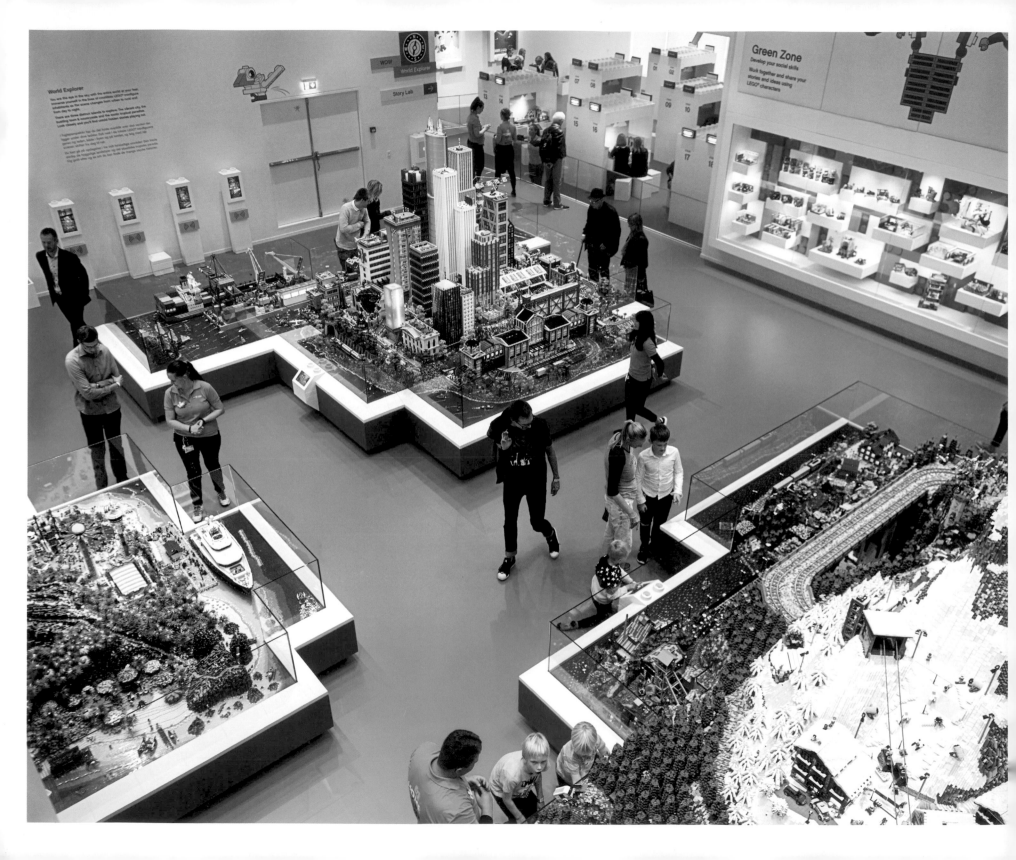

THE GREEN ZONE

From the Masterpiece Gallery, guests can start exploring the zones, beginning with either the Red Zone or the Green Zone. The Green Zone is dedicated to social competence, and the protagonists here are the minifigures, the iconic yellow characters that live in the LEGO® System sets. In the Green Zone you can build your own minifigure to express who you are in the Character Creator experience. Or you can craft your own story using minifigures and stop-motion cameras in one of the many personal LEGO movie studios in the Story Lab experience.

The Green Zone is also the home of perhaps the most spectacular experience in the LEGO House: the World Explorer. Population: 2,500 minifigures, give or take.

The idea of the World Explorer was there from the start. The team thought they absolutely needed a minifigure world. "We had been going to a lot of fan shows, so we have seen the style of fan builds," Harris told me. "The rationale behind this one was, 'Okay, look, if you gave fans an unlimited amount of bricks, an unlimited amount of time, what would they build?' The World Explorer was the answer to that question."

In total, builders used 1,973,277 bricks to create three islands: City Island, with a total surface of 228.2 square feet (21.2 square meters), Town & Countryside Island with 263.7 square feet (24.5 square meters), and Tropical Island with 122.7 square feet (11.4 square meters). There are apartments in Manhattan half the size of these islands. Everything from topography to buildings to vehicles is made of LEGO bricks, including 1,480 trees.

The model-building team—which took 2,950 man-hours to design the three islands and 24,115 man-hours to build them—wanted the environment to be as extremely detailed and immersive as possible. Rather than make these worlds static, they built a day-night cycle using 4,270 computer-controlled LEDs to simulate the rising and setting sun, a system connected by *2.5 miles* (4 kilometers) of cable. To help complete the illusion of true life, the sound team created 128 soundtracks that play simultaneously, many of which are audible only if you are right next to a certain scene in the World Explorer, and 65 of which change gradually to show the passing of time! There is a lot of movement everywhere too, with scenes in motion and trains moving along tracks—each of the latter contains built-in cameras so you can see from the perspective of a minifig conductor as the trains go around the islands. "On one level it's this impressive sort of build, but on the other it's all about the storytelling," Harris told me. "It's all about the little vignettes all over the model. The little details. The humor being the most important thing to layer on it."

Harris recalled how everything evolved. There wasn't a technical spreadsheet with all the scenes that needed to be built.

Instead, it was very much like the Tree of Creativity: They created a mood board to sketch the feel. That's when they decided to have an urban island, a tropical island, and a countryside island. After figuring this out, the team moved into the rough 3D-modeling sketch phase. "It kind of looked like Minecraft™," Harris described. While creating the 3D worlds, the design team realized they needed some features that guests could see looking down from the Masterpiece Gallery, such as the colossal snowy peak in the countryside island.

At that point the team started to think about how things would come together. After they determined the basic topography, the team then started to figure out the level of detail that was required to build on islands this massive and determine how many builders and man-hours were needed to complete it. As with the Tree of Creativity's bark, they built a 10-square-foot (1-square-meter) section of the World Explorer experience to show to Kjeld Kirk Kristiansen and the

rest of the LEGO House stakeholders. From there they set the kind detail they wanted on the trees and buildings, and the amount of lighting needed to illuminate these mini-worlds.

Once they were done with the basic palette of elements to be included in the World Explorer, it was time to bring it to life with the minifigures. The workflow was pretty simple: The island models were built in the Czech Republic while the team in Denmark created the minifigure scenes. Harris—who is based in Billund—and his local model team printed the island models on a 1:1 scale so they could place the vignettes and have them ready for the assembly stage.

The next step was to come up with the hundreds of minifigure vignettes they needed to fill the complex world they'd built. It was not a simple endeavor. "On the plane home from the Czech Republic, I would be writing more and more vignettes," Harris said. "A shopping list of thoughts." The list got longer and longer

with every trip to Kladno. Harris told me that every time he went down to the model shop to check on the ongoing construction and see the latest builds, he would see the environments and think, "That would be a great place to put a superhero" or "We should have the three little pigs there."

That organic creative process, which in the Learning Through Play model corresponds to the exploration phase, set the tone for the World Explorer. The team built stories upon stories with each iteration, developing the world narrative as they went along. Harris had a big script that detailed what they wanted to see, but added to it as the build progressed because one scene led to another. Many of Harris's ideas sprang from imagining interacting with children about how scenes relate to each other. As an example, a superhero is washing his clothes and waiting for his cape to dry in one vignette, and a robot attacks the City Island opera house unimpeded in

another, so you could ask the children to find the superhero and figure out why he can't save the city just yet.

It's extremely hard to see it all. It would take days to actually document everything they put in there. Some Play Agents have spent years working there and they still find something new every now and then. And since there's not a definitive spreadsheet detailing it all, this is a task that is entirely left up to the visitor. When I was there myself, I was overwhelmed by the amount of detail in the hundreds of visual comedy gags, the Easter eggs hiding

everywhere, and the pop culture references. My brain wanted to record it all. Oh, there's Bruce Wayne/Batman having a picnic! And there are the Beatles crossing a street as in their *Abbey Road* album cover! It is hard to know where to focus your attention because the three islands are truly overloaded with scenes and tiny details. The team knew that nobody was going to be able to process everything, but Harris said that they added all that detail anyway. It's hard not to explore it to the point at which you get totally immersed it.

World Explorer also holds LEGO Easter eggs for the employees—internal references that nobody who doesn't work at the LEGO Group will get, such as when Kjeld Kirk Kristiansen fell off his Segway and broke his leg a week before the celebration of building the highest point of the LEGO House. "We immortalized that moment with a Kjeld minifigure with a leg in a cast," Harris pointed out. "Or Jørgen Vig Knudstorp doing his little 'everything is awesome' dance at a press conference at a little plaza in the shopping area."

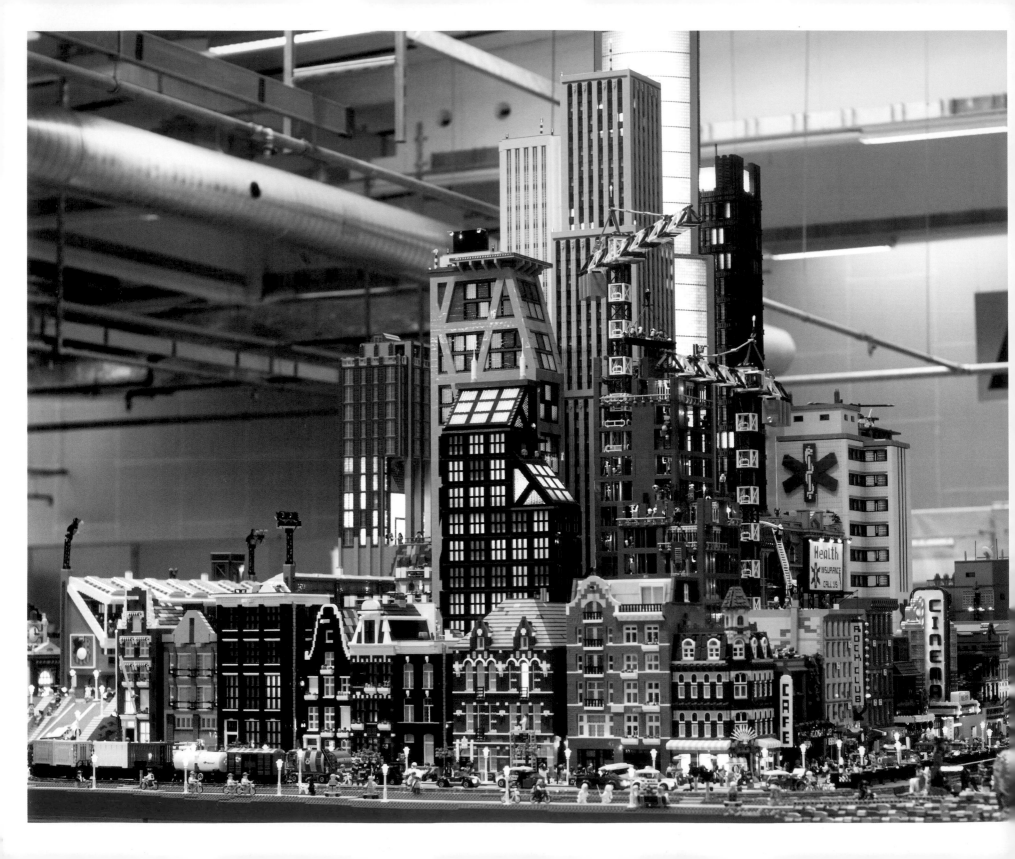

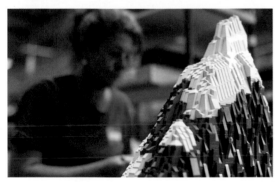

Opposite: City Island features skyscrapers, train stations, and stadiums. The mix of modern and classic architectures is reminiscent of New York City, especially at night.

Above and right: The making of an alpine landscape—soon to be finished with complex details like trains, funiculars, ski tracks, yetis, castles, mysterious caves, farm fields, and windmills.

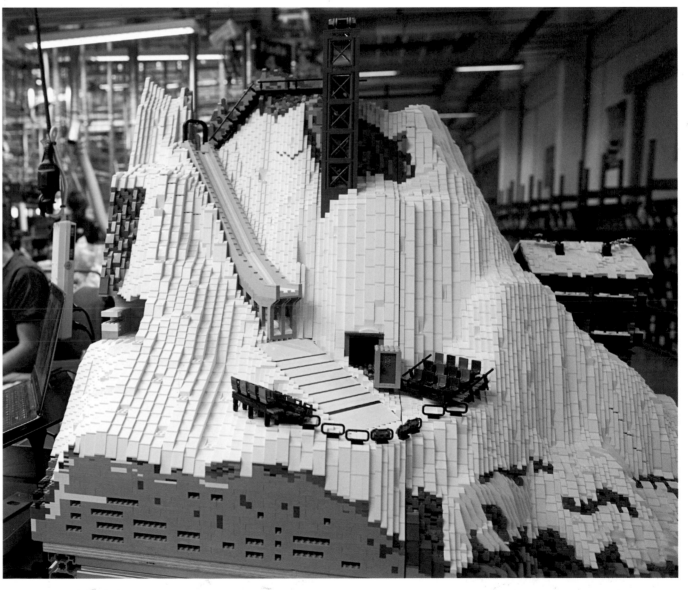

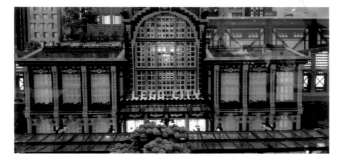

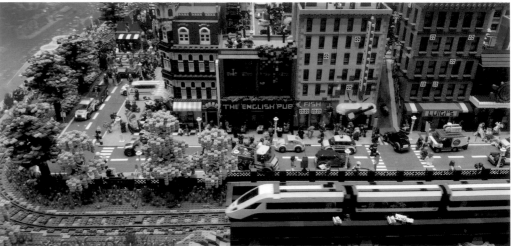

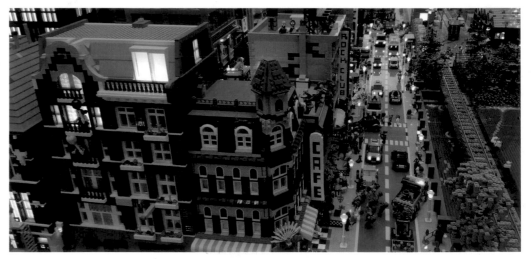

The LEGO City central station going through a cycle of day to night. The islands have LED lights and 64 speakers that play 128 audio tracks—including 40 different sound effect tracks designed to mark the difference between day and night. Displays around the islands show the view from the passing trains—they have built-in cameras that show what the conductor can see at all times.

Opposite: More than 2,000 minifigures live in World Explorer, including Batman, several LEGO employees, and the Beatles.

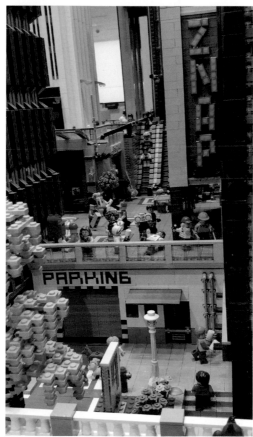

Vingnette Hunting

The World Explorer is loaded with hundreds of scenes that reference LEGO® humor or pop culture. There is not an official list. Not even the LEGO House's Play Agents or senior experience designer Stuart Harris's team know exactly how many vignettes there are, but here are a few to hunt down:

City Island

The ducks passing the street in front of the town hall are actually a reference to a famous tourism poster titled "Wonderful Copenhagen" designed in 1953 by Viggo Vagnby.

The guy with the white hair being photographed by paparazzi is Andy Warhol.

Look for E.T.—the alien protagonist of the eponymous film—calling home from a telephone booth and instead getting Luigi's Pizza's number, the pizza shop at the other side of the island.

The robot outside the theater is screaming "Bravo," a sound created using the start-up sound of the LEGO® MINDSTORMS® EV3.

In addition to Ringo, Paul, John, and George crossing the street as on the cover of *Abbey Road*, you can hear a car horn playing some notes from the 1967 *Magical Mystery Tour* song "Penny Lane."

There's an astronaut in the lighthouse talking with sounds recorded from actual NASA astronauts.

Town & Countryside Island

There's a hidden Gollum in one of the caves, the character from J. R. R. Tolkien's *The Hobbit* and *The Lord of the Rings*. If you listen carefully, you will hear him saying, "My precious."

There's a tractor that is the same model used by Ole Kirk Kristiansen.

There's a line of seven dwarves walking down the mountain singing a song that will sound familiar to fans of Disney's *Snow White*.
At night, the haunted house has scary laughter recorded by Harris himself.

Tropical Island

A song similar to the title soundtrack of the 1987 TV program *Edward and Friends* plays at the Fabuland amusement park.

Santa Claus plays "Jingle Bells" on a steel guitar by the beach.

While the World Explorer model is fully built, the work is not done yet. Like the rest of the LEGO House, it keeps evolving. The minifigure vignette team wants the design to change constantly, as in the real world. They put in different soccer matches in the city stadium, they change characters around, and when a new product comes on the market, they may incorporate it into one of the islands. For example, when the

black-and-white *Steamboat Willie* set—which commemorates Disney's first animated short with Mickey Mouse™—came out, the team decided to put it into the harbor. But they never just add the set—what fun would that be? With *Steamboat Willie*, they partially changed it by adding Donald Duck painting it in color.

Like everywhere else in the LEGO House, the Adult Fans of LEGO also participate in the World Explorer. In the Tropical Island there is a boat or vessel that comes and docks, which is built by a fan every year. The first model to dock was a superyacht created by AFOLs. In 2020 it was a steampunk submarine. By the time of publication, there will be a fan-made giant pirate ship to commemorate the twentieth anniversary of the iconic LEGO® Black Ship Barracuda set.

There is also a street parade in the city, which from time to time Harris asks a fan group to create around certain play themes. At the time of writing, there is a LEGO® NINJAGO® float and a LEGO® Castle float. Remember that robot attacking the opera house that Superman can't stop? It gets replaced with a fan-made robot every year.

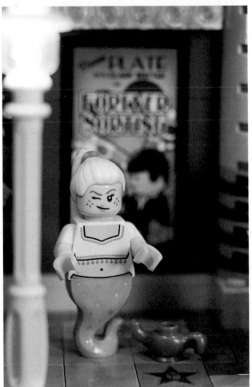

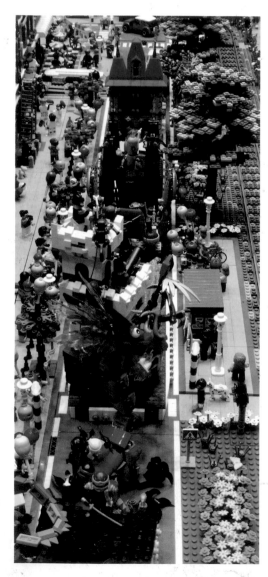

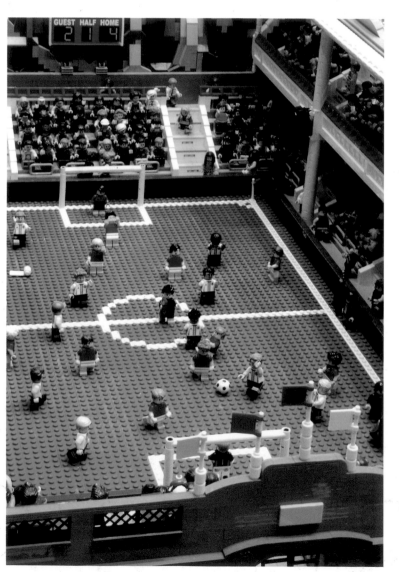

Far left: There's always a street parade happening on City Island, designed and built by fan groups around a particular LEGO play theme. The theme shown here is LEGO NINJAGO.

Left: A soccer stadium in which Denmark is winning 4-2 against Germany.

Opposite: The buildings in World Explorer have lights inside. The illumination was designed help guests imagine that there are hidden scenes taking place and life beyond what they can see.

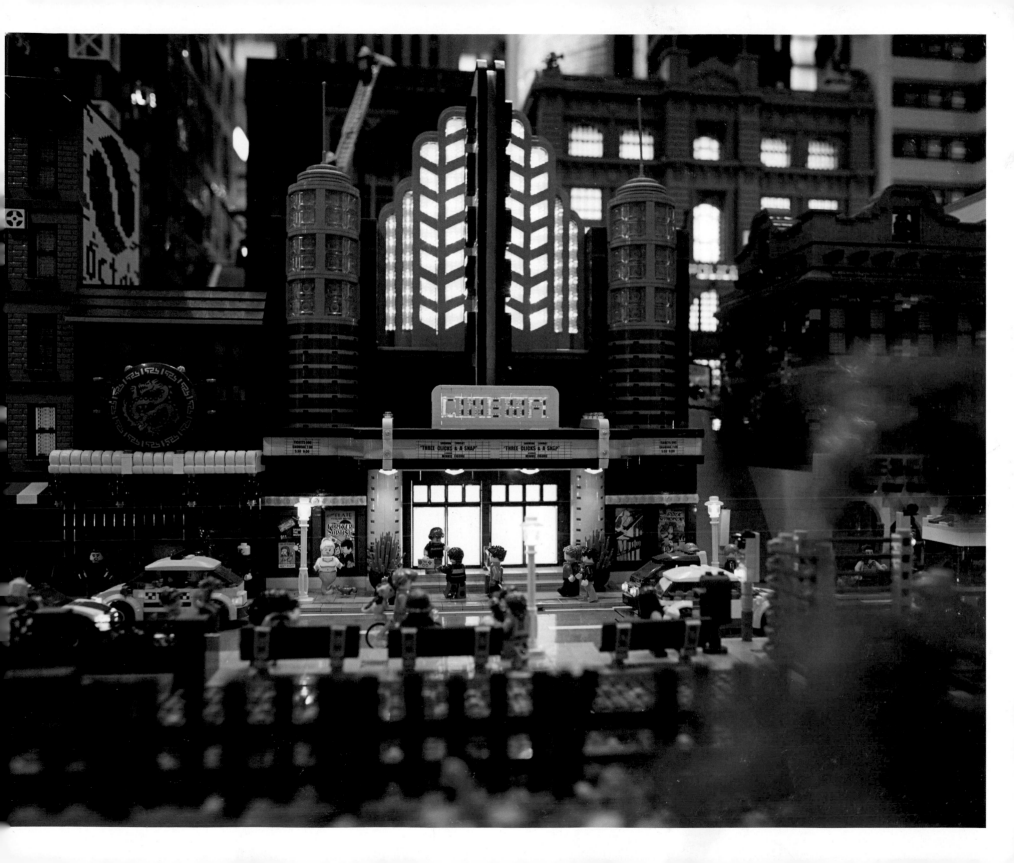

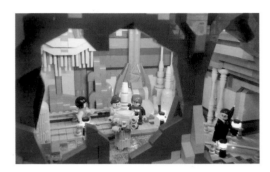

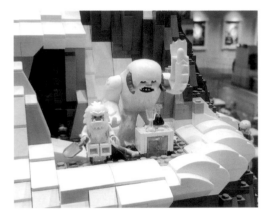

Top left: There's a hidden Gollum—
the character from *The Hobbit* and *The
Lord of the Rings*—in one of the caves.
If you get close, you will hear a voice
that says, "My precious. . ."

Bottom left: A yeti hanging out with a Wampa,
a character from *The Empire Strikes Back*.

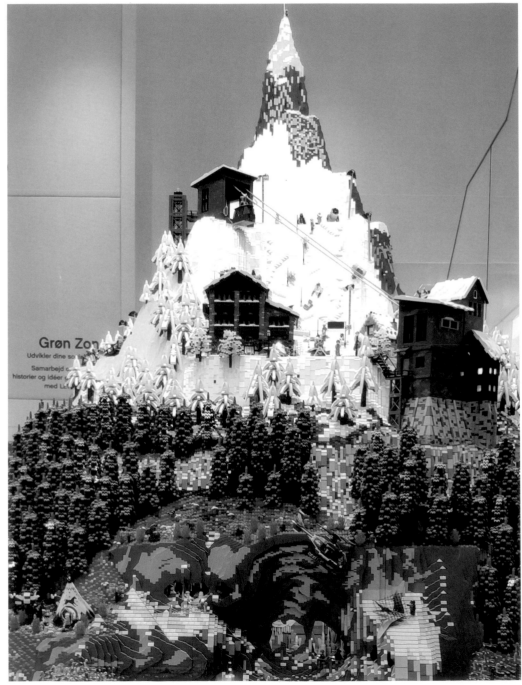

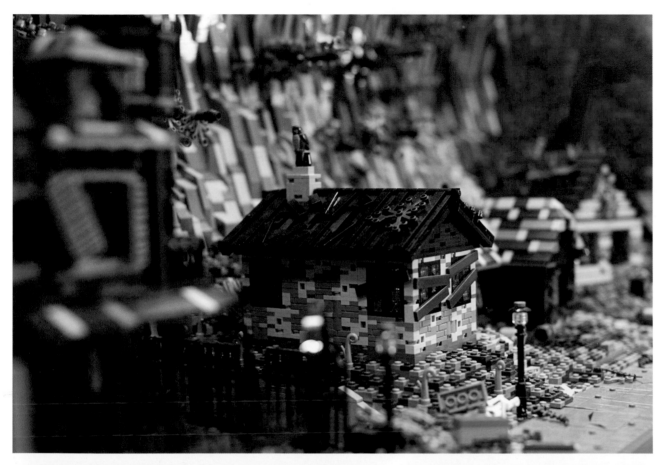

World Explorer will be endlessly developed. The model team will continue to add worlds, create Easter Eggs, and replace old scenes with new ones as times goes on.

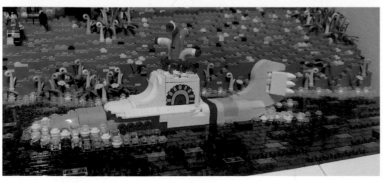

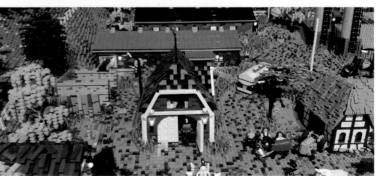

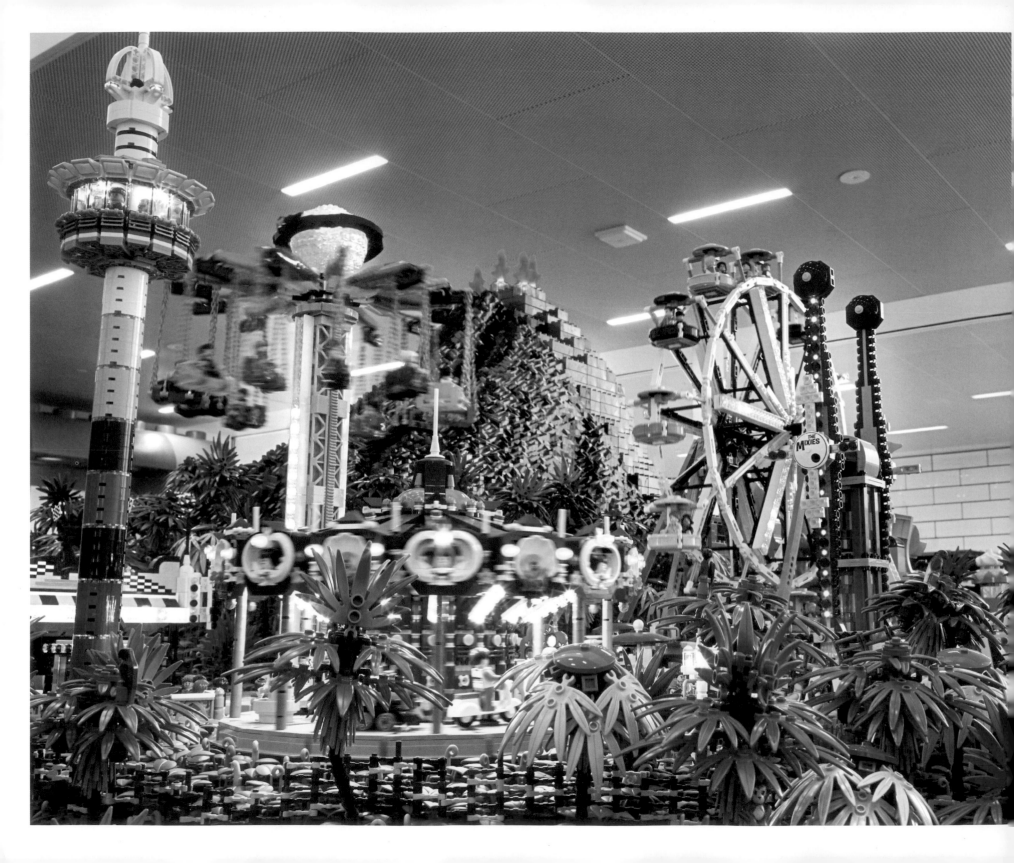

Tropical Island is built around a roaring volcano and the Fabuland amusement park—a 1979 LEGO play theme that featured animals instead of minifigures. If you look closely, you can find these little animals mixed with minifigures in the park.

The back part of the island—which is next to a LEGO DUPLO building area for toddlers—is actually built with LEGO DUPLO bricks. Since the two types of bricks share the same proportions, the two sides of the island merge seamlessly.

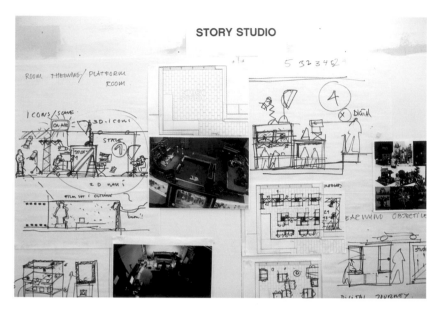

STORY STUDIO

Story Lab lets guests take a seat in the director's chair and direct their very own LEGO stop-motion movie. Booths have different themes and guests build their own minfigures and pick props to fill the scene. Three digital cameras record different angles of each original movie.

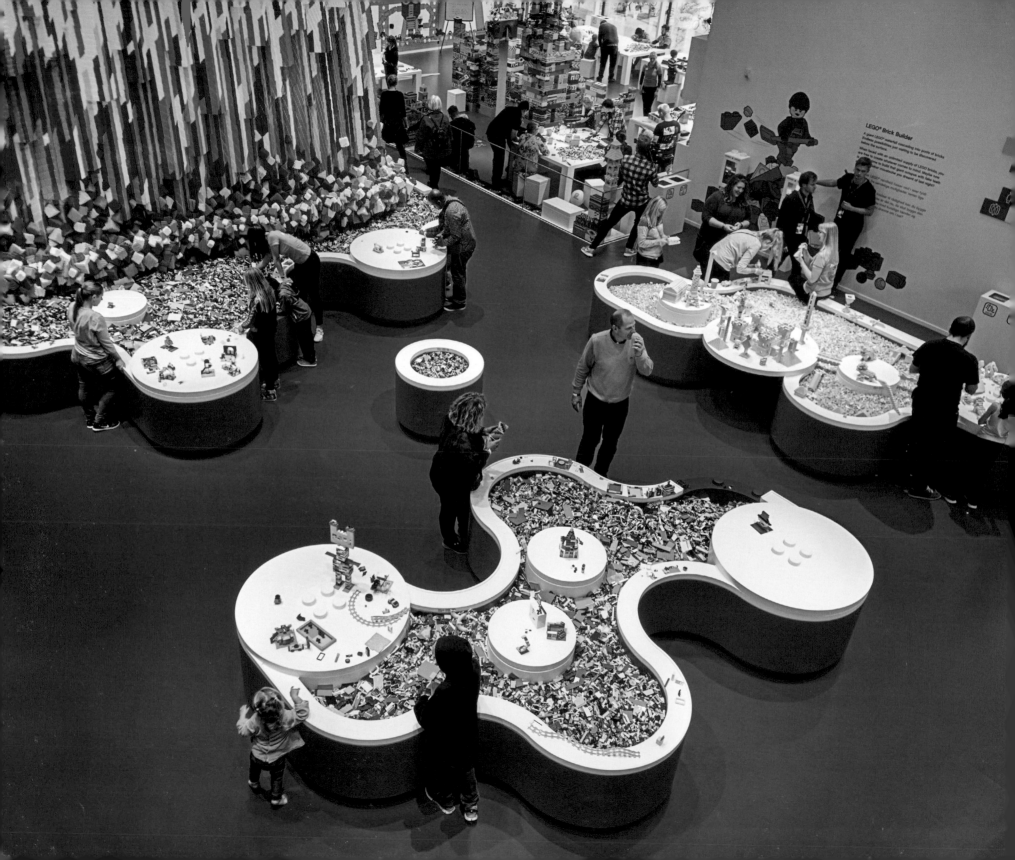

THE RED ZONE

If you choose the Red Zone path toward the section of the house devoted to creativity, you will encounter the stunning LEGO® Waterfall, an epic waterfall made entirely of bricks in six classic LEGO colors—white, red, green, yellow, orange, and blue—that "fills" an enormous pool full of bricks in the same colors. With a height of almost 20 feet (6 meters), it is so tall you can walk right under it. It is the *"wow" moment* of the LEGO Brick Builder experience. The fall has a twin in the DUPLO® Waterfall, which serves the same purpose in the DUPLO Brick Builder experience.

The third Red Zone experience is the Creative Lab. The concept is easy: Give a set of LEGO elements to guests to build a model around a specific theme. The theme changes over time. When I visited the LEGO House to write this book, the theme was starships. According to Harris, selecting which elements to include in the Creative Lab is a hard process. The lab needs to create enough of an open-ended building experience without providing too many pieces or restricting the process too much. "You have to find the right balance between the elements," Harris explained. What are the key pieces that fit naturally with the theme, and how do you keep people from spending too much time rummaging through piles of pieces?

There's no exact formula for this. It comes from the experience of building over many years, knowing the pieces, and knowing the many ways people can use them. "With the starship, we knew we needed a lot of grays, a bit of black, and bit of white, and you have the angle ones," Harris told me. "I usually start with too many and then I ask myself what can I take out."

This zone also holds the LEGO Library, in which you can just sit down and unwind for a bit, looking through books about how people use LEGO bricks to create anything you can imagine.

The Brick Builder experience is a simple concept: giant pools hold tens of thousands of LEGO bricks of all colors. But its design and engineering is anything but simple. The main feature of the room, the LEGO Waterfall, is one of the biggest and most spectacular constructions in LEGO House.

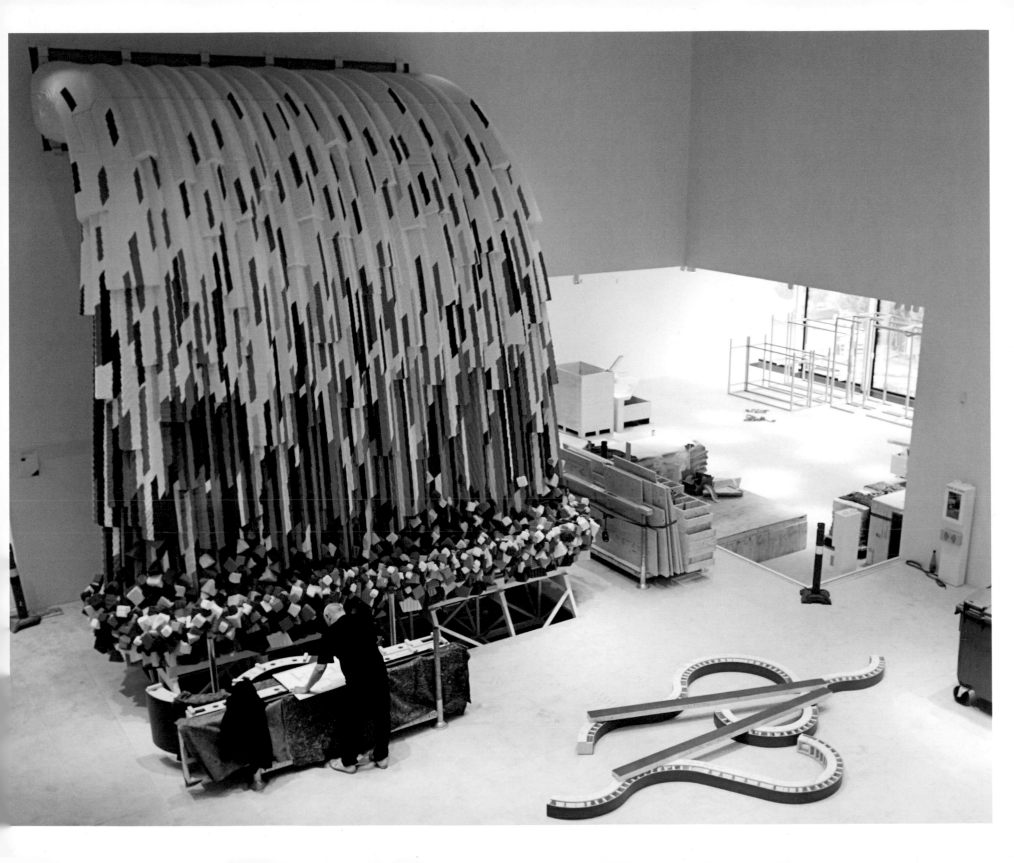

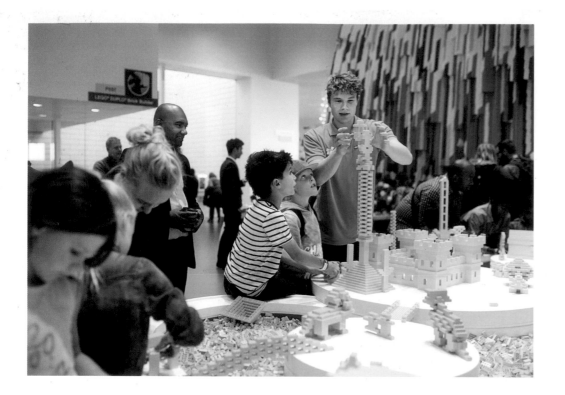

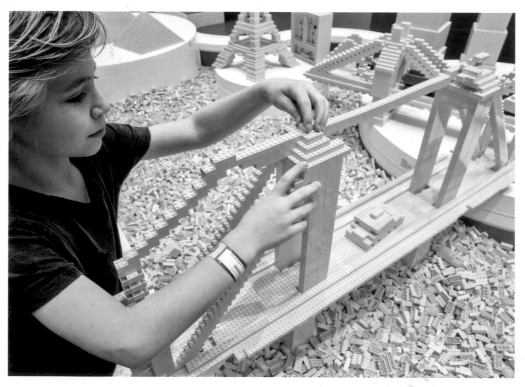

The Red Zone is dedicated to exploring creativity, with LEGO brick as the medium of expression. The goal is to build guests' creative confidence, so LEGO House Play Agents often spend time by the pools, encouraging guests to turn wild ideas into reality. The Play Agents then select the best guest builds to feature in a temporary exhibition gallery by the Waterfall.

THE BLUE ZONE

The zone dedicated to our cognitive skills houses the Test Driver experience, in which guests can iterate the design of a car to be fast and durable, and the DUPLO® Train Builder, which gives toddlers an unlimited number of tracks and train pieces to stimulate cognitive abilities.

The Blue Zone is also home to the City Architect and Robo Lab experiences. The first allows you to create your own city by building little modules. Each module corresponds to one of four different types of city zoning: Red is for housing, green is for public gardens, yellow is for industrial buildings, and blue is for commercial structures. In the Robo Lab, guests were originally tasked with rescuing a mammoth trapped in ice by using basic computer commands on a remote-controlled robot. In January 2021, Robo Lab was updated to feature a new robotic adventure starring bees and flowers.

The LEGO® House data shows that these two experiences, plus the Fish Designer—located in the Yellow Zone—are the most popular. The three have something in common: They merge the digital and physical worlds.

There was no expectation of digital integrations in any of the experiences except for Robo Lab, which obviously was going to have the digital element of controlling the robot using a touch screen. The digital design team's objective was to add a digital layer only if it elevated the experience, not just for the sake of it. The team thought that any digital elements should be driven by the zones themselves and by what they could add to the Learning Through Play model.

One example of this design process is City Architect. The design team started with the actual surface to build the city blocks. From there they thought through how to put constraints on that surface, so that guests could build a city collaboratively for twenty minutes with certain limits and a common objective. It was only then that they turned to digital integration as a practical solution to build in constraints and goals. The digital layer became a way to draw the grid for the city and add in active building prompts—live minifigures that could run around demanding more of a certain kind of city block. Blue minifigures would ask for commercial areas, while red minifigures would demand housing, and so on.

Digital lead Mads Mommsen believes that one of the reasons why these digital-physical mash-ups are so popular is because they give guests an opportunity to do something with LEGO bricks that they can't do at home. The LEGO House's complex systems of projectors and sensors help create the unique mix of digital and physical magic that can't be replicated elsewhere.

Right and opposite: The Test Driver experience is a great exercise in problem solving. Guests must experiment and develop solutions to real-world challenges as they build and refine their unique vehicle. One track is designed to test speed while a second track requires a vehicle to shoot through a central hoop and survive the jump.

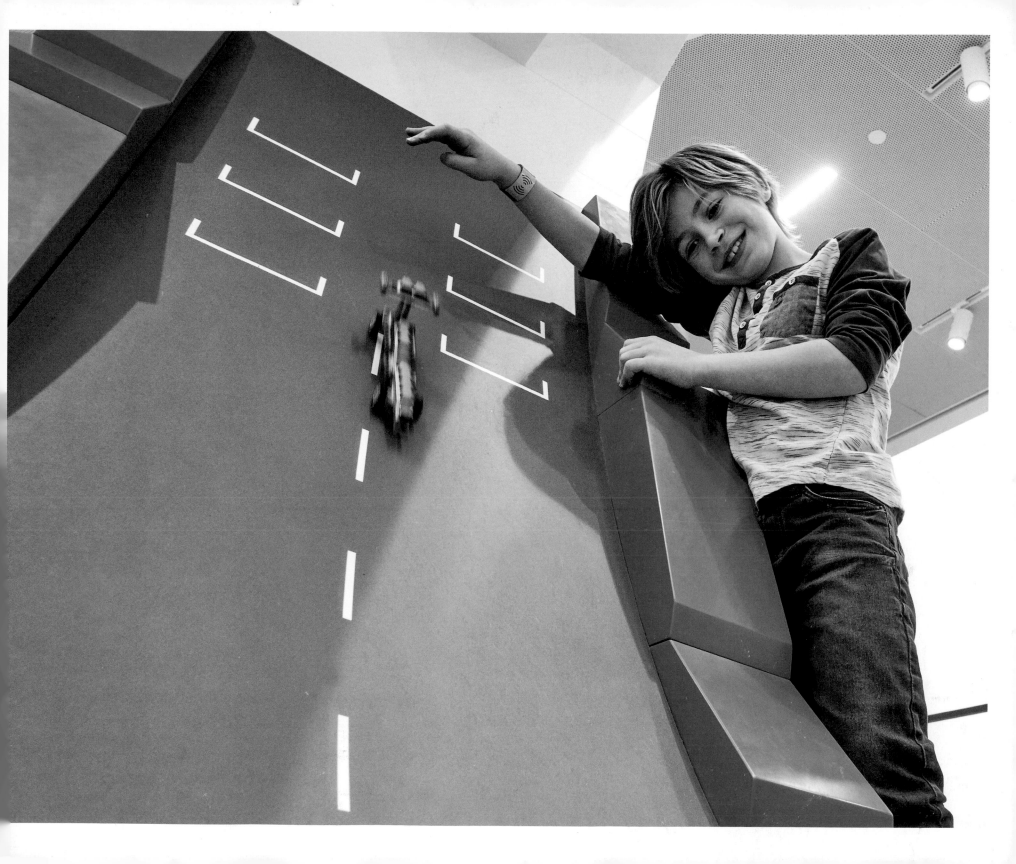

Blue Zone
Develop your cognitive skills

Challenge your problem
solving abilities. Test your
ideas ...and try again to
discover your optimal
LEGO® solution

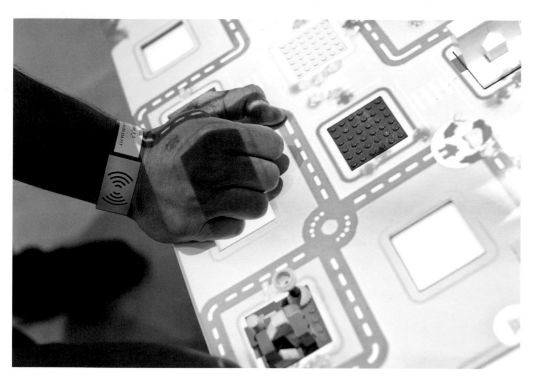

City Architect is a simulator for creating lively urban environments. It asks guests to plan their own cities by building and placing real LEGO buildings on top of digital plans projected onto tables. When you place a new building to meet the demands of the city's minifigure citizens, the table reacts. New streets materialize to connect the new structure to the rest of city. City Architect is designed for collaborative game play—guests of all ages work together to build a balanced urban landscape.

Robo Lab combines the physical and digital world, utilizing the hugely popular robotics platform LEGO MINDSTORMS. The focus is problem solving, but instead of building guests control robots using a very simple programming language. Unlike every other experience in LEGO House, the time in the Robo Lab is limited. When the time runs out and the experience ends, guests can see the results of their programming efforts on the front page of a digital newspaper.

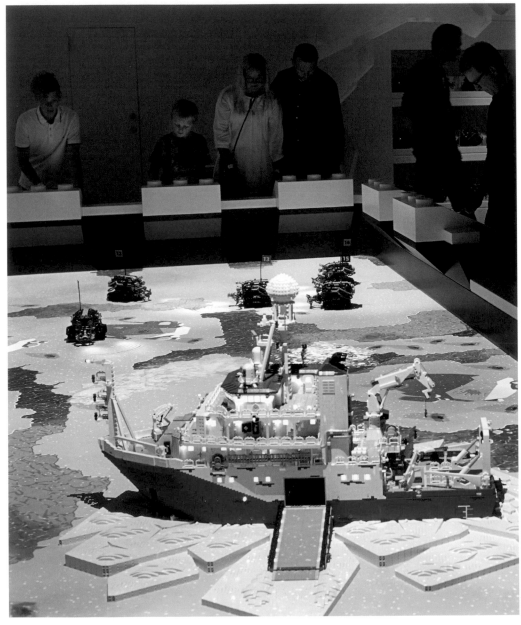

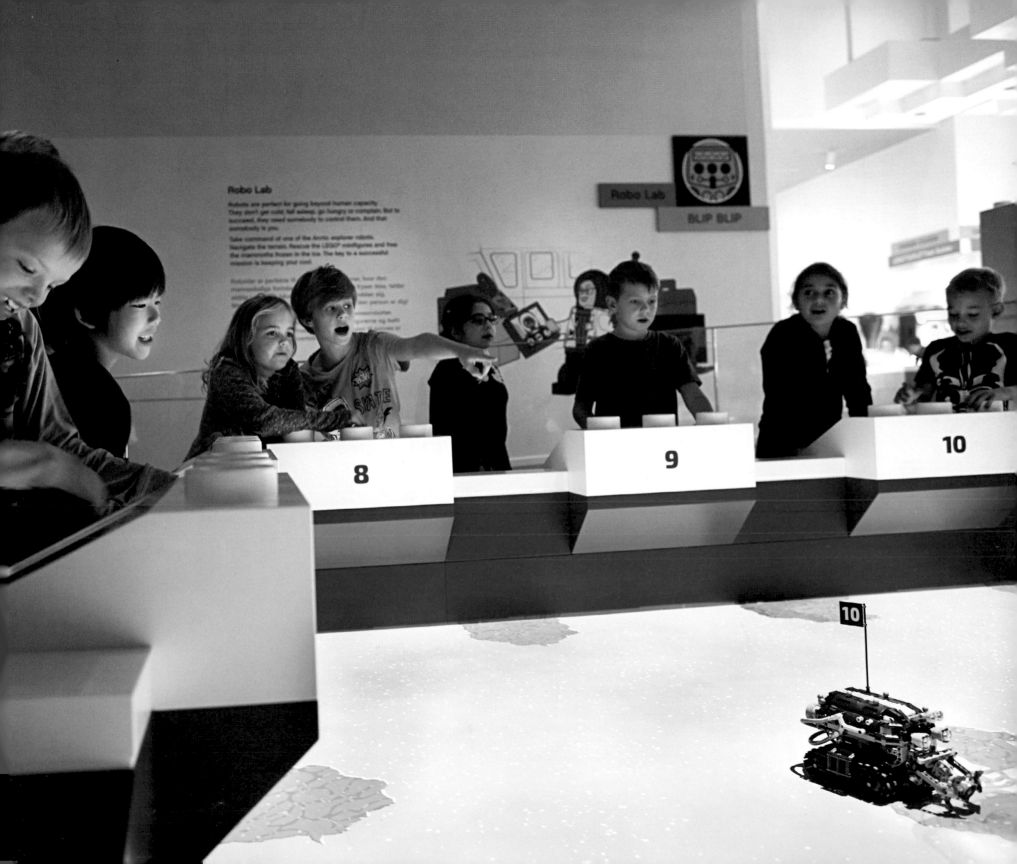

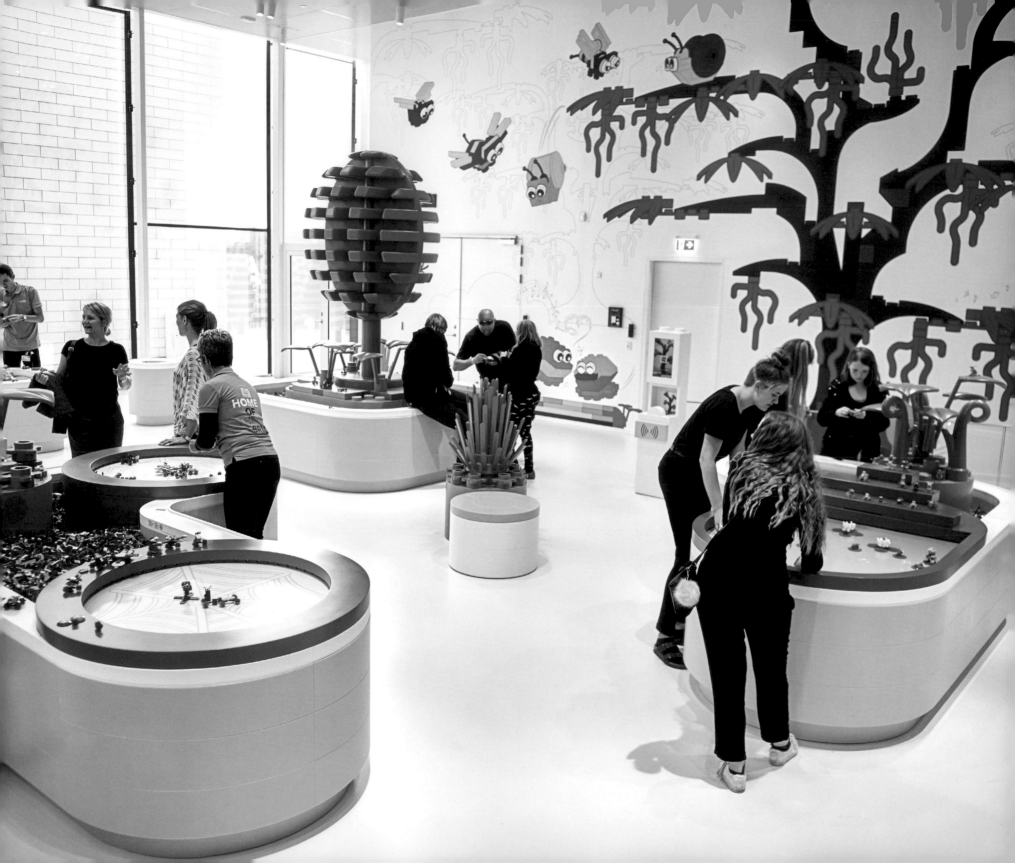

THE YELLOW ZONE

This area contains the most intimate experiences in the entire LEGO® House, as guests explore their emotions through different sensorial experiences. In the Flower Artist, for example, a stunning flock of butterflies in all colors, patterns, and shapes floats over a field of flowers, inviting guests to contribute their own LEGO flowers to the scene. To see these many creatures and flowers is an overwhelming visual experience. And contributing to it makes you feel happy and part of something great and fun. The Critter Creator allows guests to make little bugs that respond to sound and vibration, which brings an inexplicable joy to children and adults alike. The DUPLO® Mood Builder lets toddlers express their emotions by creating their own butterflies with happy or sad faces.

The Yellow Zone also contains the most popular of all the experiences in the LEGO House: the Fish Designer. In this experience guests are invited to use bricks to build their own fish on a flat surface. Once they are done, guests can capture it using a digitizing unit and, through a touch screen, add eyes and mouth so the fish can express emotions. Visitors can then set their fish free into a large water tank made of multiple large OLED displays. The fish can swim freely and interact with other fish created by other guests, as well as other elements in the environment.

It's a deceptively simple concept, but one that makes children and adults smile in awe. I ask Mommsen if he thought that maybe the attraction to the Fish Designer was a part of a cultural change in terms of how kids perceive the world and interact with it through digital displays. Mommsen believes that this is indeed the case. Kids today have a curiosity about screens, he said. They have an immediate need to try things out whenever they see one. They gravitate to it and think, "What can I do?"

With this in mind, the design team put a lot of effort into making the Fish Designer's digital elements part of the connect phase, especially the large aquarium and the digitizing station. The displays in the Fish Designer are not multipurpose devices, Mommsen told me, but single-purpose elements that fit in the overall workflow of the experience. The digitizing stations, for example, are just a way to transform the physical model into the digital fish. The displays that show the aquarium are just that: a window into another dimension where your LEGO fish actually lives. Those screens, by the way, were one of the biggest technical challenges in the LEGO House. According to experience development manager Søren Hansen and senior experience designer Rikke Ranch Høgstrup, it was very hard to find the right displays so the fish would be visible from all angles. The team managed to find them with only days to spare until opening day!

Mommsen believes that the younger generation's passion for digital displays is

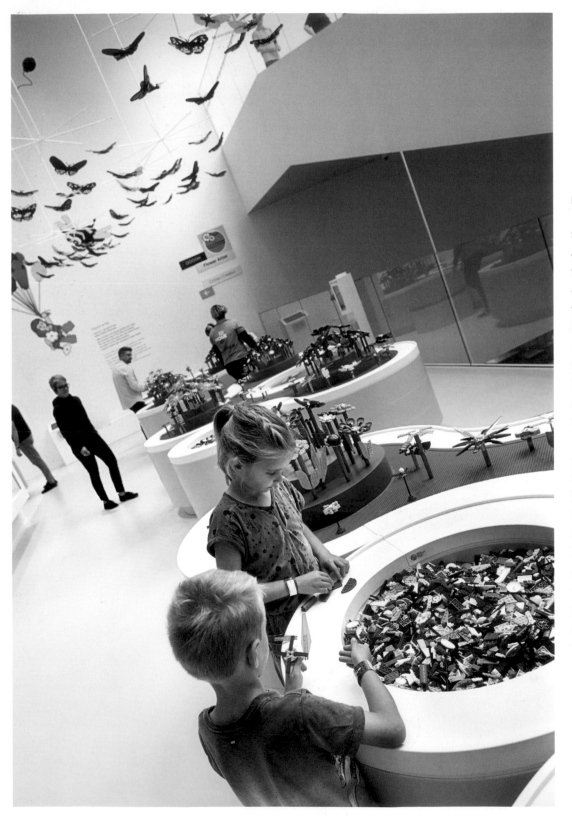

something that is not going to go away any time soon. The digital and physical worlds are merging more and more with every passing year and with every new technological achievement. But he also believes that physical toys in general will never disappear. "It's a challenge, but I don't see it as a threat," he told me. "This is one of the things we are doing, showing some of the potentials of these two words merging."

Ultimately, one of the goals of a digital-physical experience such as the hugely successful Fish Designer is to show that integration can be an inspiration source for LEGO play in general. Mommsen's hope is that the Fish Designer—like Robo Lab or City Architect—sparks inspiration within the company. If anything, the digital part deepens the immersion process by expanding the physical world, using an ever-changing, interactive layer to create a new augmented reality.

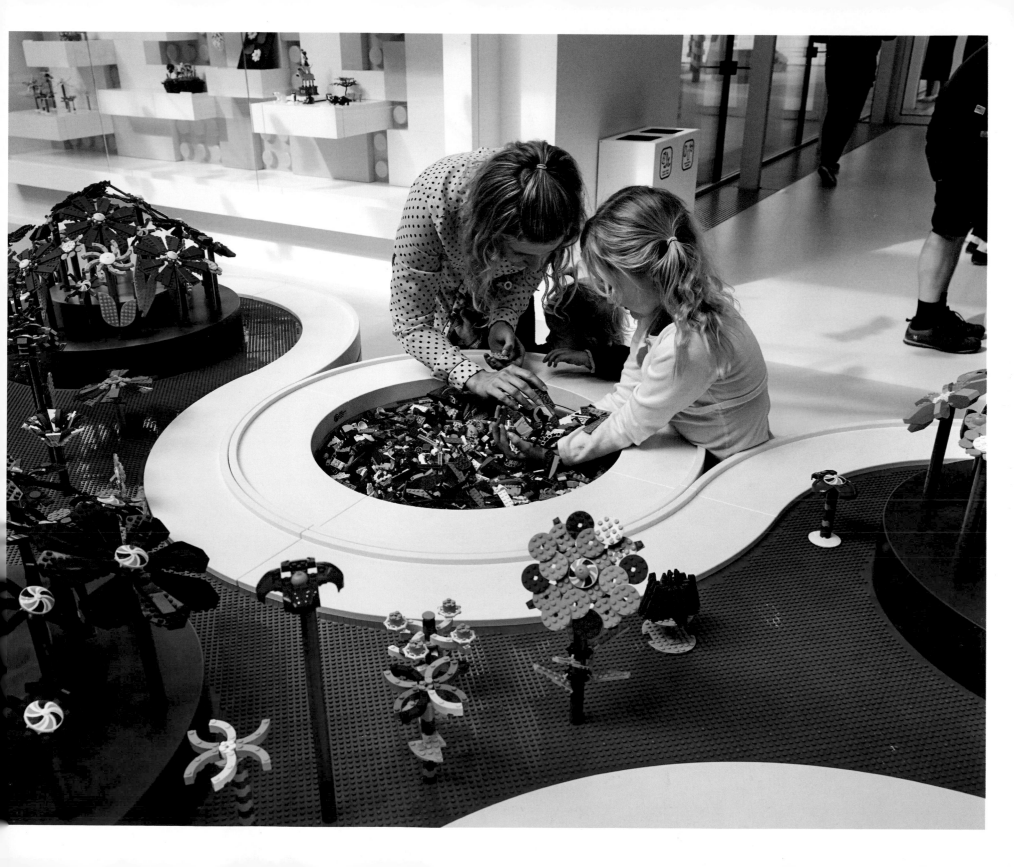

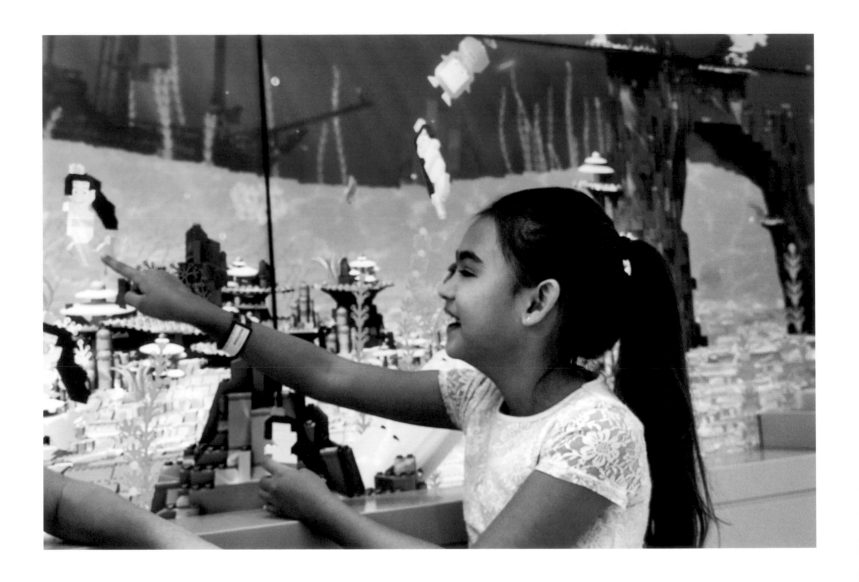

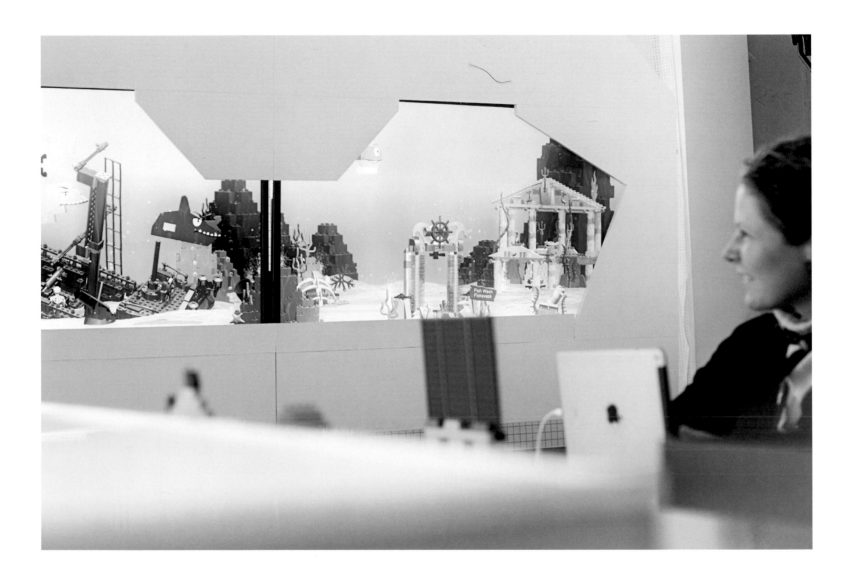

Previous spread: In Fish Designer guests can build their very own LEGO fish and see them come alive in a huge aquarium. This is the most popular experience in the entire LEGO House, an activity that combines the construction and a digital interface. The "wow" moment is impressive: LEGO fish, rendered in real time as fully animated 3D models, zoom across the water, exploring their surroundings and interacting with other fish.

Above, left to right: A colorful build turns into a digital wonder. In addition to choosing eyes and mouths, guests can give their fish an emotion—it directs how the fish will behave when it encounters different situations in the digital sea.

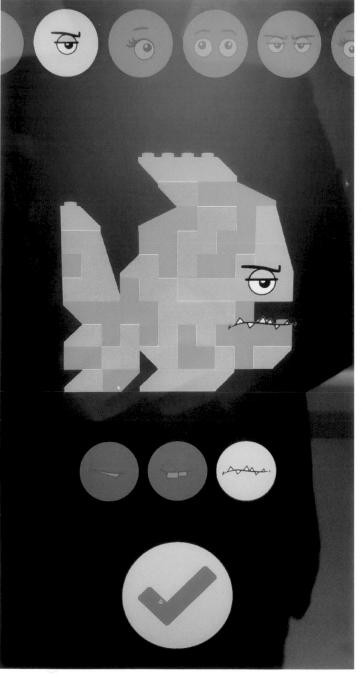

AHA!
An intellectual and emotional breakthrough.

After you have completed your adventures in the four zones, you will find yourself back on the ground floor. There you can take two routes. Either go to the side stairs and walk down into the History Collection—a path that we will take in the next part of this book—or leave the LEGO® House through the Farewell Zone.

In this area, an ABS plastic-molding machine—just like the ones they use at the LEGO factory—churns out red 2x4 bricks all day long. The machine wraps these red bricks in packages of six, a fun memento that Play Agents give to each visitor before they leave the exhibition areas of the LEGO House.

While this may seem like an innocuous parting gift, it's much more. That package of six red bricks are the summary of all the experiences in the LEGO House, the purest definition of what the LEGO System is—and a mathematical lesson too.

See, next to that molding machine there is a digital station. When a guest places their RFID wristband near the reader, the station prints a personalized card that shows a randomized 3D combination for those six 2x4 red bricks next to the guest's name. It is their own personal LEGO build.

There are 915,103,765 ways to combine six 2x4 bricks, as discovered by Danish mathematician Søren Eilers[1]—a very curious guy who solved this problem in 2004. That means that, at the typical visitor rate, the LEGO House will run out of combinations in three thousand years.

But most importantly, the six red bricks represent the nearly infinite power of the LEGO brick as a way to create *anything* you can imagine. If you can combine six 2x4 red bricks in 915,103,765 ways, try to comprehend what you could do with two hundred bricks. Two hints: In 2012, another mathematician named Johan Nilsson calculated that you can create about 816 trillion combinations with *nine* bricks of the same color. And Eilers later concluded that it would take five billion years to calculate the total number of

Opposite: A brick-built homage to the Kirk Kristiansen family.

Next spread: A display case of six-brick builds lines the Farewell Zone.

[1] Chris Higgins. "How Many Combinations Are Possible Using 6 LEGO Bricks?" February 12, 2017. http://mentalfloss.com/article/92127/how-many-combinations-are-possible-using-6-LEGO-bricks

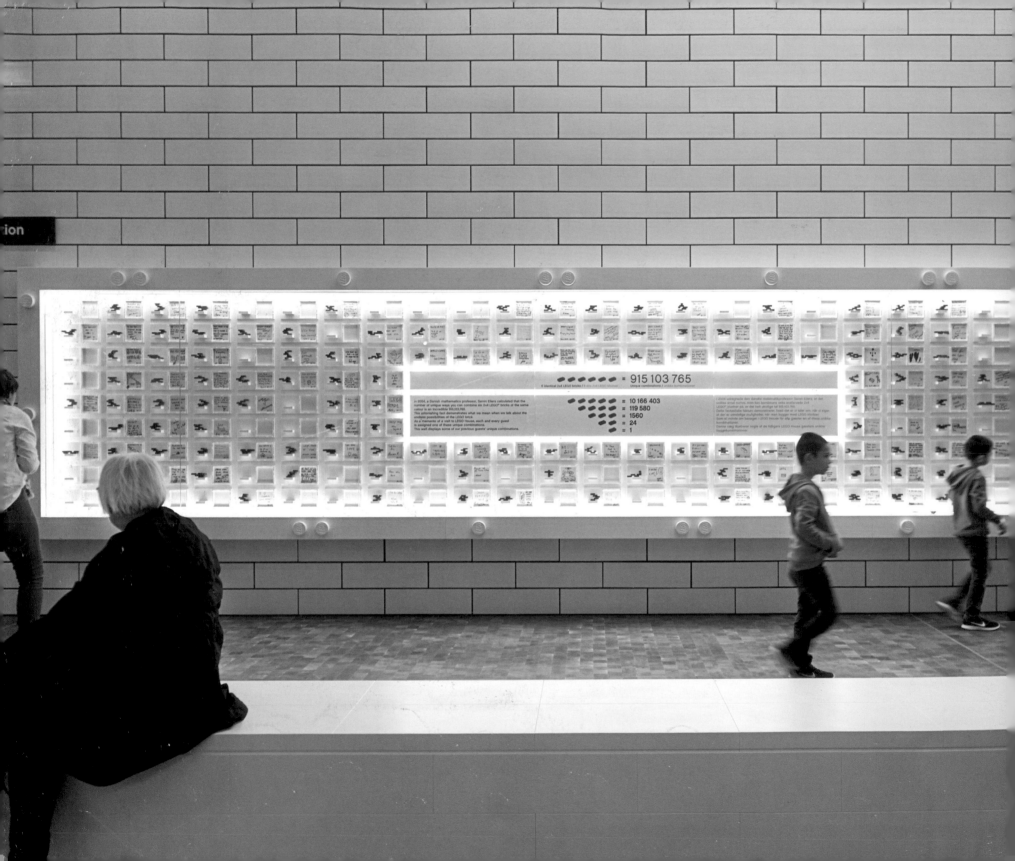

combinations of twenty-five bricks using current computer architectures. The Sun would swallow the Earth before we could get the solution.

And thus we reach our *"aha!" moment*—the breakthrough moment in which guests realize that there are no boundaries to what you can do with LEGO bricks. Not only because these bricks open up unlimited building possibilities, but also because guests have experienced this infinite potential in their journey through the LEGO House.

Public Space

Exiting the experience area after the ABS plastic–molding machine, the visitor returns to the public town hall area. Both LEGO House guests and Billund's citizens spend a lot of time here. It's an airy, open space full of seating, LEGO sculptures, and murals. A coffee shop called BRICKACCINO offers sandwiches, good coffee, and a selection of Danish pastries. There is a restaurant on a higher floor called CLICK DINER. There is also an informal restaurant called MINI CHEF in which you can place your order using colored bricks that you feed into an optical scanner. A few minutes later, your food will fly out of the kitchen in a kind of bento box that looks to be made out of LEGO bricks, descending from the ceiling to the delivery area via a conveyor belt system. At the end, two LEGO® MINDSTORMS®–like robots push the boxes to the hungry guests who wait, numbers in hand, thinking about what they experienced in the Home of the Brick and probably wanting to get back to the zones after they finish some rather delicious food (try the slow-cooked pork if they have it).

The most surprising part about getting out of the zones and back into this open space, however, is the fact that the LEGO House doesn't force you to go through the typical merchandising shop, like almost every other museum and exhibit in the world. Sure, there is a LEGO shop that opens into the public town hall, but I didn't even notice it the first time I entered the building or left the paid experiential areas. Perhaps it's because it blends with the rest of the elements of this public plaza so seamlessly. Or maybe I was so engrossed with the LEGO House journey that my brain didn't even register it.

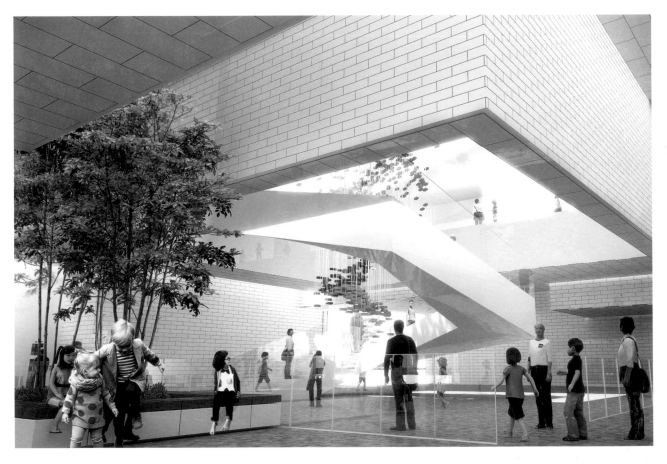

A digital rendering of the ground floor, before the Tree of Creativity was designed to fill the central staircase.

Opposite: A busy day in LEGO MINI CHEF Café.

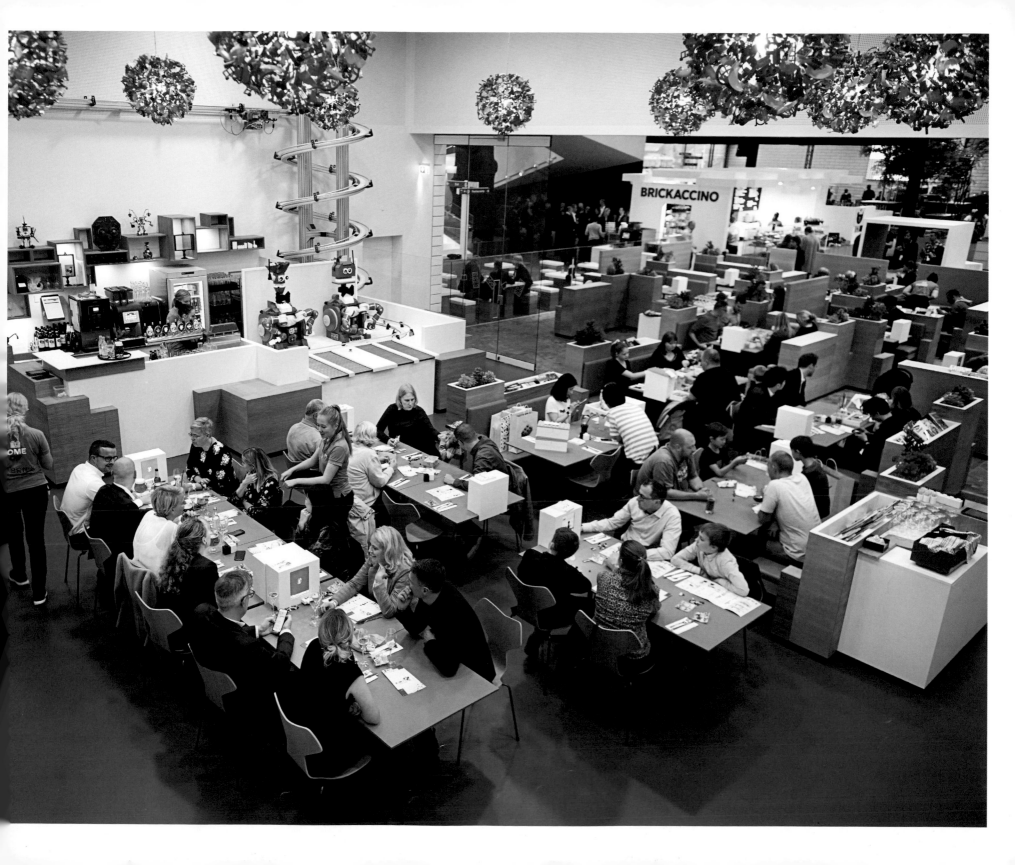

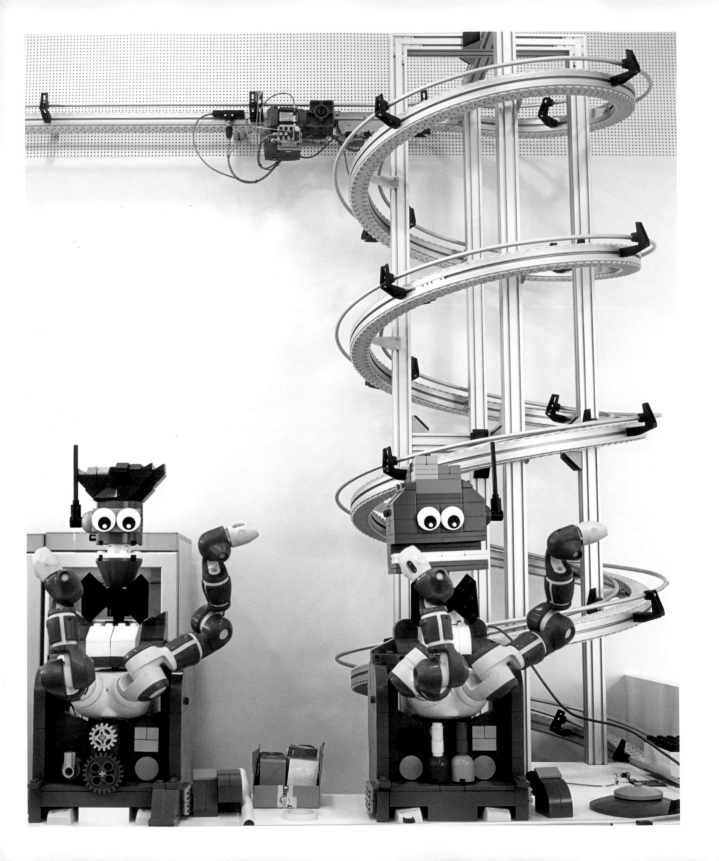

LEGO robots serve up delicious dishes for hungry guests.

Opposite: Guests build their orders using bricks that correspond to specific foods.

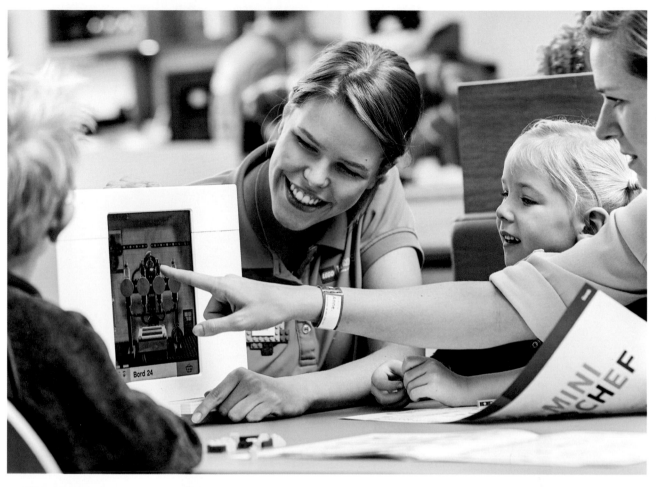

PART III:
TRANSFORM

THE END.
The heart of the LEGO® House.

The timeline that runs through the History Collection can be read at different levels. Guests can go from a bird's-eye view, just focusing on the year and descriptions of each era, all the way down to ultra-close reading of the small text that details each artifact.

But let's not say farewell just yet. There is another place you must visit at the LEGO® House: the sancta sanctorum of the Home of the Brick. Its very heart, the place where your childhood dreams sleep, as head of the Idea House Jette Orduna described it in 2008. The secret vault, as I called it back in that first Gizmodo article. Or, as the signage says, the LEGO History Collection.

Influenced by the original Memory Lane secret vault I visited on my first trip to Billund, there has been a spot reserved for the History Collection in the foundations of the LEGO House building from the very beginning. According to Orduna, it had to be a place with no windows for two reasons. First: They needed an exhibition space. Second, and most important: It had to feel intimate and special, just like the original vault.

As you walk down the stairs to this wondrous lair, the first thing you notice is that the building walls gradually change to black, the brightly colored bricks randomly disappearing like pixels in an old video game, the vibrancy of the upper floors diminishing in intensity. Most people come to the History Collection after running, building, and playing with their kids all day in the rest of the LEGO House. The design calls to families to come and experience a moment of respite and quiet; the dark color palette and dim lighting helps everyone calm down together. "We wanted to create the atmosphere of this actually being a treasure vault and for people to have a moment of peace and reflect on what the LEGO experience is all about," Orduna said.

The second thing you notice downstairs is the silence, especially after all the sounds of joy and laughter in the upper levels. "People are very respectful here because [the vault] is part of themselves," Orduna told me while leading me to the new History Collection. "But it's nothing sacred and we don't want it to be sacred like a church." The design

team wanted people to talk aloud, but instead, guests whisper. Orduna believes that they are so quiet because it feels like a very special place. And it is a very special place indeed, as special as the original secret vault that I visited more than a decade ago. Unlike the secret vault, the new History Collection doesn't contain all the sets ever made. But its dimly illuminated walls and sober architecture make it feel more solemn and important than the original, like the company's sancta sanctorum where the soul of the LEGO brick sleeps.

The design team first started working on a 5,382-square-foot (500-square-meter) room, which is not a lot of space if you want to create an exhibition with lots to tell. The History Collection tells the entire history of the brand in a time line. It also contains the most important sets in the history of the company. But at the beginning it wasn't that way. "We had a time line, we had a space for a special exhibition, because we wanted something for people to come back to, and then we had an area telling everything about the LEGO Group, Orduna told me. The design didn't work, so they tried four or five more iterations to outline what they wanted to tell. While the company has a good backstory—going from humble beginnings to a hugely successful global company—there is much more to it than that: "We asked ourselves if we could add something more, and how we would place the elements of the exhibition," Orduna explained.

At the end of their brainstorming, they rooted the History Collection in the emotional experience that people have in the original Memory Lane vault. The team realized that, if they wanted to connect with the visitor, they needed to create a space where the product is the center of the exhibition. Not the company, but the sets. And they did this because the sets are what connect with people's memories and emotions— "like you experienced the first time you came to the vault and like what has happened thousands of times since then," Orduna told me. Here, it happens to everyone. The team decided to display the most important sets from the company's history in carefully designed shelves, much like crown jewels are displayed in a historical museum. Around this new secret vault they told the LEGO story as a time line, as if it were a background narrative that explains the existence of these jewels, the childhood memories of millions. You can dig into that time line if you want to, but you can also ignore it and marvel at the sets that speak to you. Once they realized that the time line didn't need to be central to the exhibition, everything else fell into place.

A TOUR OF THE HISTORY COLLECTION

As you enter the History Collection, you immediately find your first treasure. All you need to do is look down. On the floor, behind thick glass panels, there are metal molds buried in the ground. The LEGO Group used to bury their old brick molds in concrete so they wouldn't be stolen and sold to competitors. The company doesn't do that anymore, but a few years ago, when work started on a new building and an old factory was torn down, the workers found some of those molds buried in the old foundation.

As you raise your eyes, you'll spot the next impressive sight: a giant LEGO® logo made with LEGO elements. Rather than making a logo the easy way—the typical mosaic made of straight LEGO bricks—this epic 6.5-square-foot (2-square-meter) logo is made of 1,638,498 irregularly shaped LEGO elements, from wheels to wrenches to paddle boards and everything that is not a rectangular brick. It took one person— the expert model builder Abdallah Kobeissi, who has been working at the LEGO Group for more than four decades—nine months to build it. The elements are set on five different layers, each of them carefully built and glued together. In total, it weighs 275 pounds (125 kilograms) and it includes some historical elements that only true LEGO fans would be able to detect and identify.

As you turn to your left, you encounter silhouettes of children and statements on the importance of play projected on the walls. On the ground there are enlarged LEGO bricks—molded in the same 1:18.75 scale and made of Kerrock, continuing the impression that the entire LEGO House is made with actual scaled-up LEGO bricks. In fact, even the display cases—which were created by the Bjarke Ingels Group—follow the golden standard of the LEGO House: the 2x4 brick proportions. The size and proportion of these glass cases imposed some limita- tions on the selection of objects and sets that they could display, but in the end everything they wanted to feature fit perfectly.

Then, on the space's gray concrete perimeter wall, the time line of the LEGO Group's journey starts. The curation team stayed totally honest in telling the company's story, because authenticity is the only way to connect with people, Orduna told me. It was a company that came from poverty and crisis, and it was against the ropes again following two big downturns in 1999 and 2004. Pointing at one photo of founder Ole Kirk Kristiansen, Orduna told me that they cheated about only one thing: "We erased the cigars from some of the photos."

The curation team designed the time line to offer different levels of depth, so guests can actually walk fast toward the core of the History Collection where the sets are stored, getting an impression of the company's history as they pass, or dig into as much detail as they want.

The LEGO Group is a family-owned business, so each phase of the time line is represented by one generation of owners, starting with Ole Kirk and ending with the fourth-generation owner, Thomas

Kirk, who took the helm in 2016. The time line also features quotes from the owners that show that the LEGO Group is more than a company that just sells toys. Here is one from Kjeld Kirk Kristiansen himself: "LEGO play stimulates creativity—it stimulates the ability to translate images of the mind to real expressions in the real world. In a way, LEGO bricks are a bridge between imagination and reality."

Then, each decade of the time line is marked with a golden LEGO brick and a panel that shows the context of that decade so people can interpret what the company was going through at the time. Even if you read only this one element, you will get a good impression of what the company history is.

The next level is the artifacts. Guests can stop and read all the details next to original toys such as the wooden duck or some early LEGO prototypes that have never been shown to the public before. Guests can view anomalies such as a policeman made of wood that is ten times the size of a minifigure, the first LEGO® DUPLO® bricks ever designed, and the first BIONICLE® drawings. There's also the mold for the motorcyclist minifigure and the first prototypes for LEGO trains, one of the early cornerstones of the company.

The last level of detail—right at the bottom, next to the floor—is a space that displays brick-built reproductions of the artifacts above. The recursive idea is to show that you can make everything with LEGO bricks, even the LEGO Group's own history.

The time line is also full of Easter eggs, some of which only the most passionate LEGO fans will find. Sharp-sighted guests will see the only set designed by Kjeld Kirk Kristiansen that became a product: a model of an early 1960s Jeep-inspired car.

And of course, there are references in the History Collection for hard-core fans, such as the Inside Tour sets, or a collection of minifigures that represent LEGO fan clubs, with minifigures of Kjeld Kirk Kristiansen and chairman of the LEGO Brand Group Jørgen Vig Knudstorp standing right next to them.

Orduna revealed there is one last secret at the end of the time line, hiding in plain sight: There's a secret hole built into the wall to expand the time line whenever that's needed in the future.

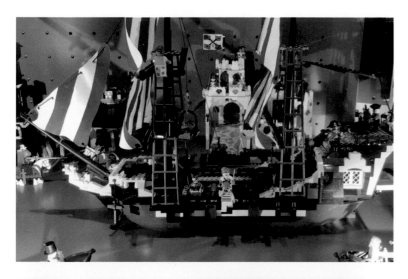

Just a few of the treasures in the History Collection: (top) the LEGO Black Seas Barracuda set, released in 1989 as the first set in the Pirates play theme and (bottom) some of the very first LEGO sets, including the original LEGO Town Plan, which featured a young Kjeld Kirk Kristiansen on the box.

Learning Through the Yellow Duck

LEGO® Education, the LEGO Foundation, and the Learning Through Play model are also in the time line in the form of a case full of different builds of a simple yellow duck.

The company often uses this duck-building game as a way to demonstrate how Learning Through Play works to new employees or special visitors. According to Orduna, visitors are given six bricks and asked to build a duck in thirty seconds. That's the connect phase.

According to her, there's no right way to build the duck, so options are limitless. But when guests get the bag of bricks, they panic because they think they can't build a duck that quickly without instructions. As soon as they open the bag, their mind fires on all cylinders. In the blindingly fast explore phase, their hands start moving instinctively, as the brain knows how to build the duck even if only subconsciously. Feet, body, head, bill— the duck comes together as the guest must visualize, plan, and build seamlessly.

And at the end of the thirty seconds, everyone has their own version of a duck. "These are all ducks," she said, pointing at the shelves. "Are any of these ducks wrong? No." After they are done, guests start a dialogue because they have to explain to others why their ducks look that way—the transform phase of the Learning Through Play model.

THE MONOLITH

As Jette Orduna said at the beginning of the tour, the most important part of the History Collection is the sets. For this they needed to build a very special part of the secret vault, a space that looked as if it were supporting the entire LEGO® House because the products are what support everything in the LEGO brand. They called this space the Monolith: a giant, dark gray 2x4 LEGO brick that mirrors the white brick of the Masterpiece Gallery at the top of the LEGO House.

Bjarke Ingels was very involved in the creation of this place because, as a LEGO fan, the secret vault was a personal passion of his. Aside from designing the shelves that hold the sets inside, he also found a huge walk-in round vault door from an old Danish bank to use within the design. His idea was to enter through the vault door to see all the treasures of the History Collection, Orduna told me, "but we said no." The idea was fun, she said, but they thought that psychologically it wouldn't work—it's a barrier between the guests and the treasure. She believes a vault door would have missed the whole point. The LEGO bricks are a treasure because you connect to them.

As you enter the Monolith, you can look up to see the brick's eight knobs and the number 3001 set in golden metal— the part number for this 2x4 brick. At its center there are the bricks' three tubes, in this case cylinders tall enough for a child to look inside. But instead of dinosaurs as in the Masterpiece Gallery, one of them is full of the most significant LEGO train models, another has a digital screen, and the third tube contains the most iconic LEGO Technic models ever made. On the digital touch screen you can navigate through almost every set made by the LEGO Group. They painstakingly photographed every side of every box in the original Memory Lane vault under the LEGO Idea House, assembling the images into 3D boxes that guests can turn and view from all angles on the digital screens. People use these screens to search for their favorite sets, create a collection, and send it to the cloud using the RFID wristband. That way, when they get home, they can look at the LEGO boxes from every angle.

The reason for these virtual collections was that they couldn't fit all the LEGO sets ever created in the History Collection. The team looked at LEGO fan sites from around the world and researched which sets were the most popular. From there, they made their own selection because they also needed to include LEGO® DUPLO® and LEGO® Technic sets that are historically important even if they might not have the same iconic status.

On the two short sides of the Monolith there is a temporary exhibition space to showcase collections of sets. This section changes from time to time for people who come back every year—it featured LEGO® Star Wars™ sets

when I was there, to celebrate the twentieth anniversary of the first LEGO *Star Wars* set, model 7140, the first LEGO X-Wing released in 1999.

The permanent collection is set on the longer sides of the 2x4 brick, displayed on glass-enclosed shelves arranged in vertical panels that evenly zigzag at 45-degree angles across the walls. The fully built models are displayed on one side and their respective boxes on the opposite side. "We show the box and set, because we know that the box is as equally as important as the set," Orduna pointed out. "That's what happened to you when you saw the box of the Galaxy Explorer." The design is very clever: If you look from one side of the vault, you will see only the fully built sets. If you look from the other, you will see only the boxes. But the visual effect

is not just for fun. Orduna claims that they designed it this way so guests would be near each other while looking at the shelves, close enough to talk about the sets they had and share stories about them.

Everything in the History Collection needs to be permanently maintained by Orduna's curation team experts: "They need to know which little minifigure belongs to what, or otherwise you will have thousands of letters pouring in saying this is wrong." She explained that people send emails from time to time because they have detected mistakes in dates or labels. There are mistakes that people don't notice as well. In fact, Orduna secretly knows one but she won't tell. Her team won't fix mistakes until they get a letter. It is somewhat of a treasure hunt for LEGO fans.

Since they couldn't use the sets from the original secret vault—which are securely stored in their boxes for historical preservation—the curation team had to anonymously buy some sets off the internet. That was the case for the LEGO® Galaxy Explorer, which, according to Kjeld Kirk Kristiansen, is the most iconic set ever made. The curation team is also tasked with adding the top ten best sellers of every year, so as time goes by, they will have to compress the collection to make space for new sets.

"There's a good story here," Orduna told me after ending our tour through the LEGO House. But really it's two stories, she explained, the story of "you," the person who plays with the sets, and "us," the LEGO Group represented by its sets. You can't have one without the other.

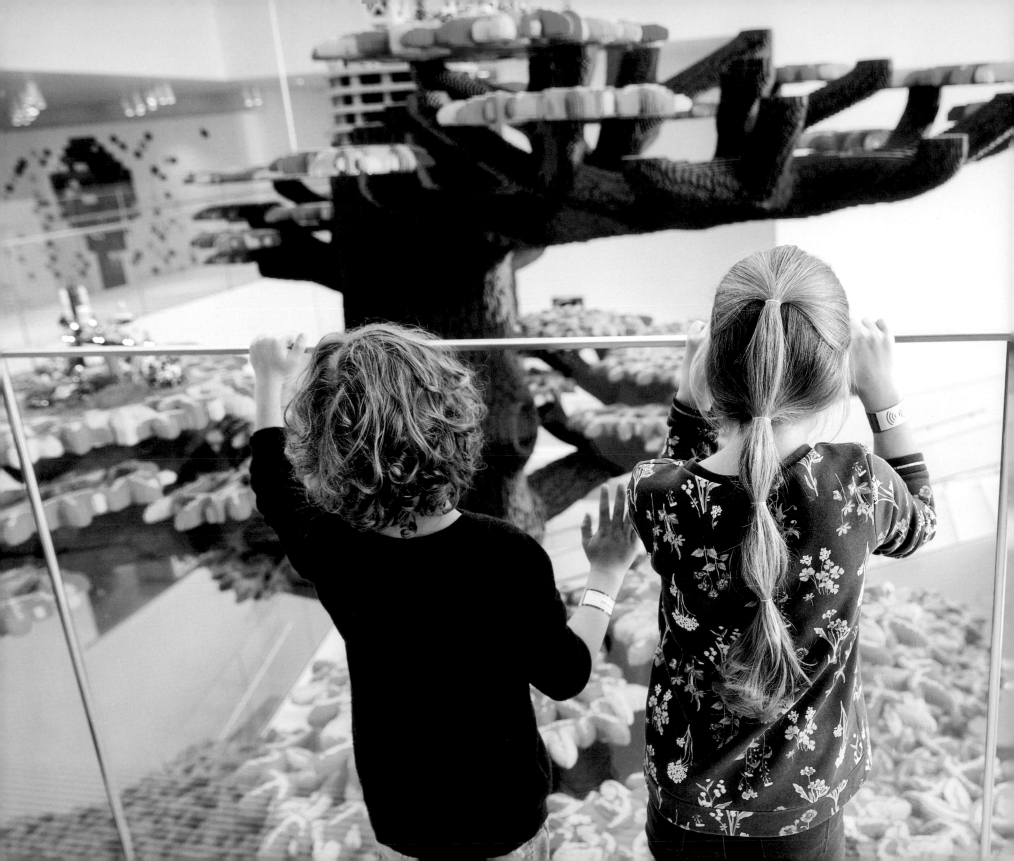

LASTING IMPRESSION.
Changing lives one brick at a time.

As I sit at the desk in my hotel room, writing some quick impressions after spending a day in the LEGO® House, I keep coming back to one singular idea: the Learning Through Play model that permeated every last brick living inside. It truly is the great secret of the LEGO House—hidden in plain sight.

Call it an epiphany if you have to, but my own personal journey to the LEGO House and through this book has been a realization that playing with LEGO bricks in my childhood years was a key element to my development and understanding of the world. It definitely set me on a path of curiosity about how things work, which later got me into technology, and pointed me toward a career in writing about it. This, in a delightfully circular way, set me on a collision course with the LEGO brand, the secret vault, and this very same book you are holding.

I can imagine that many people who go through the LEGO House will have a similar experience, without being able to put words to it. And this was ultimately the final objective of the LEGO House, the realization of Kjeld Kirk Kristiansen's vision for the Home of the Brick. This place is not only a space to have fun and learn. It is also a place of transformation. Maybe not for everyone, but there is a decent chance that many children may make a career choice based on the LEGO House and its experiences. As head of experience development Mike Ganderton put it, what if a kid wants to become an architect, film director, or industrial designer, and in the future they realize that there was a moment in the LEGO House in which they decided to move in that direction? Rikke Ranch Høgstrup, LEGO House's senior experience designer, agrees that LEGO House could be pivotal to a child's life path. The best part would be if kids came back in twenty years and told them that they made a decision to be an engineer or an architect because they learned something about themselves at LEGO House.

The Tree of Creativity is purposely left unfinished. As the tree tells the story of the company, it couldn't be topped out. The designers decided to make it obvious that the tree was, of course, artificial and made of LEGO bricks. A crane and construction site at the top reveals that the model is actually being built by minifigure workers.

Everyone I spoke with for this book believes that LEGO bricks are what truly guided them. After all, this has been the power of the brick since Ole Kirk Kristiansen and his son Godtfred started to manually mold them in Billund. The Home of the Brick couldn't be anything else but the expression of this secret life-changing power—the power of Learning Through Play.

SHARING.
The secret is in your living room too.

Everyone who has played with LEGO® bricks knows about their unique power, but it's hard to put the exact feeling into words. It took me thousands of words and still I think I fell short. Perhaps it's that, sometimes, simple things are hard to explain.

The LEGO House is one of those hard-to-explain things too. Amazingly, everyone who spoke with me for this book said something similar, especially when I asked them to define what the LEGO House actually is, in their own words. Managing director Jesper Vilstrup told me that they had invented something that is hard to define because it hasn't been made before. You can't say it is a museum. You can't say it is a fun house. You can't say it is an experiential center. Because it's something that is a bit of everything and yet completely different at the same time. Head of experience development Mike Ganderton shared the same thoughts. LEGO House senior experience designer Rikke Ranch Høgstrup explained that it's not just a

home for the brand, but for others around the world to see how important Learning Through Play is. "Play matters," she told me. "It's about discovering and knowing yourself through playing."

Jørgen Vig Knudstorp, chairman of the LEGO Brand Group and one of the main steering forces for the LEGO House along with Kjeld Kirk Kristiansen, had a similar non-definition definition. He said that the LEGO House is such a unique place that there could only be one. It's like nothing before it because it's about the LEGO brand and what the Learning Through Play ideal is. It can't be reproduced anywhere else because it has to have an epic narrative that is intimately tied to the brick itself. It is not about business, but about idealism—about putting something back into society. About making a stand and showing the world what play, learning, and life are all about.

Those are lofty words. But they don't miss the mark. It seems to me that perhaps there are only two ways

Next page, top: BIG's design proposal for LEGO House included a detailed mock-up of a LEGO Architecture set, shown here. The dream of LEGO House was then made real by a massive collection of creators and builders. To bring it full circle, in 2017, LEGO House became actual LEGO Architecture set, #21037.

to discover what the LEGO House is.

One: Come to Billund and experience the center of the LEGO universe yourself if you haven't yet. Or two: Go get those LEGO bricks you have stored somewhere in the basement. Buy any set and throw away the building instructions. Ask for six 2x4 bricks from a friend if you have to.

In the end, Learning Through Play doesn't exist in a single place. Its power is not confined to a colorful building in Billund, Denmark. You can experience the secret power encoded inside the LEGO House right in your own living room, bedroom, or kitchen table. It's right there, in your brain and in your hands, every time you put together a LEGO duck, a tiny Galaxy Explorer, or any of the 915,103,765 things your imagination can make with six 2x4 bricks.

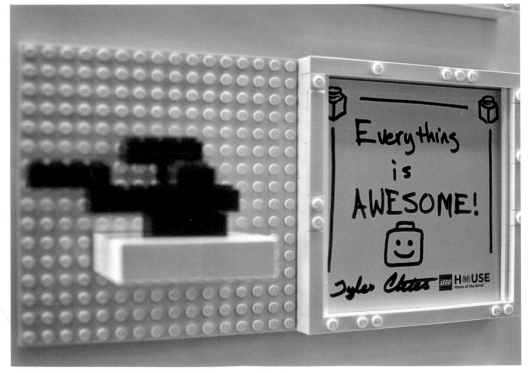

About the Author

Once upon a time, Jesús Díaz was considered one of the 25 most "viral" journalists on the internet (back when viral was a good thing). His writing about technology, space exploration, astronomy and all kinds of LEGO® news amassed more than one billion views in six years, helping to define the voice of Gizmodo.com. He later founded Sploid.com, a blog about eye candy, read by more than 45 million people each month. Now he writes and produces at The Magic Sauce, the film and TV studio he co-founded.

Jesús lives with his family in Madrid, Spain, where he spends his time writing screenplays, building LEGO dinosaurs and spaceships with his son Max, and eating all kinds of strange seafood like barnacles and purple shrimp heads. He still wants to be an astronaut one day.

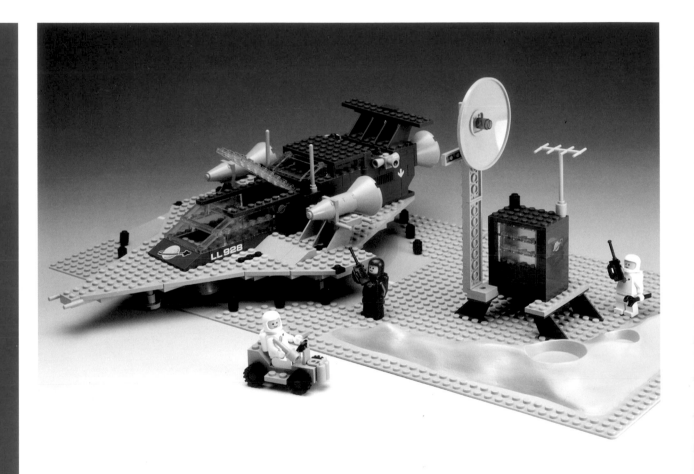

3 1901 10065 0888